IMAGES
of America
LAKE COUNTY

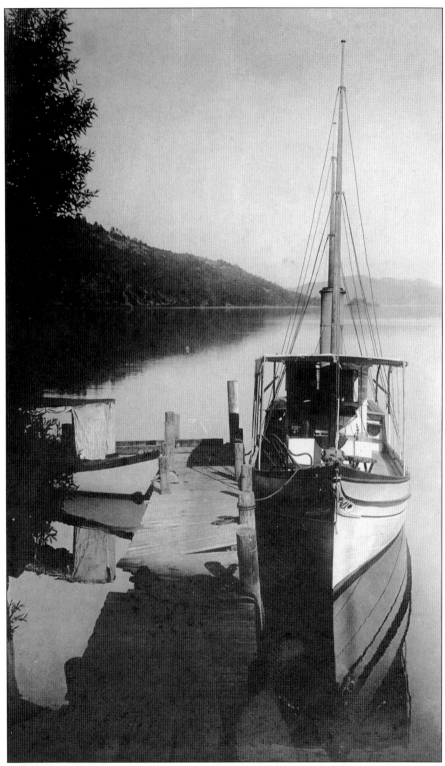
Capt. Richard Floyd's steamer *Whisper* sits quietly at the dock at Kono Tayee.

Marcia Bishop Sanderson and Maureen Garcia Carpenter

Copyright © 2005 by Marcia Bishop Sanderson and Maureen Garcia Carpenter
ISBN 0-7385-3030-1

Published by Arcadia Publishing
Charleston SC, Chicago IL, Portsmouth NH, San Francisco CA

Printed in Great Britain

Library of Congress Catalog Card Number: 2005927068

For all general information contact Arcadia Publishing at:
Telephone 843-853-2070
Fax 843-853-0044
E-mail sales@arcadiapublishing.com
For customer service and orders:
Toll-Free 1-888-313-2665

Visit us on the internet at http://www.arcadiapublishing.com

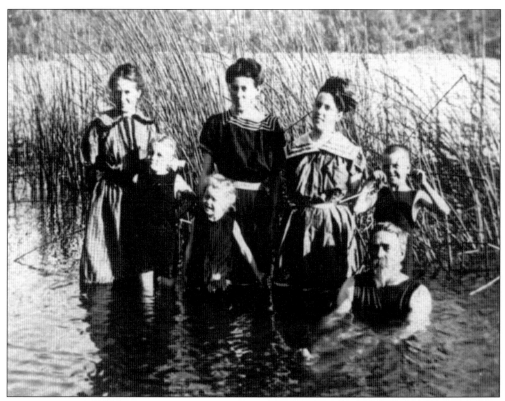

The Wambold family enjoys an afternoon swimming in Clear Lake at the beach on Craig's Island.

Contents

Acknowledgments 6

Introduction 7

1. Clear Lake Basin Beginnings 9
2. First Settlement 15
3. New Arrivals 31
4. Mountains and Springs 39
5. Shore to Shore 53
6. Towns and Valleys 67
7. Sports and Recreation 107
8. End of an Era 119

ACKNOWLEDGMENTS

Lake County is blessed with many people who enjoy history. As we began to gather the pictures and stories for this book, we delighted in finding many, many rich resources from which to draw. We have only skimmed the surface for this overview of our county.

We encountered an out-of-town researcher who commented to us, "I've been tracing the history of my family in many places across the United States. Lake County has the best records by far." Very early on, the "Sunday Brunch Bunch" inspired confidence that this was indeed a "doable" enterprise. In particular, Bill Beekman of Nice loaned us a copy of Donald Edmondson's master's thesis, "History of Lake County to 1890 with Emphasis on the Native Population." Our sincere thanks to the Lake County Museum, the Friends of the Museum, the Lake County Historical Society, the California Historical Society, and the California State Archives for access to their files and for their research assistance.

Friends and family pulled out dusty photograph albums. We reminisced and laughed as we turned the "pages of our past." Steve and Claire Ledbetter, Larry and Camille McDaniels, Joe and Ramona Evans, Lee and Sandy Bucknell, Marylee Muns, Jan Stokes, Vic Barnes and Wilda Shock with the H. Vincent Keeling Photo Collection, Anita Crabtree, Barbara Vengley, Myron Holdenried, Billy Anderson, and Trett Bishop contributed vintage photographs, and K. C. Patrick offered steadfast support and thoughtful comments that helped us write the manuscript. Thank you. We hope you enjoy this book about this place we all fondly call home.

—Marcia Sanderson and Maureen Carpenter

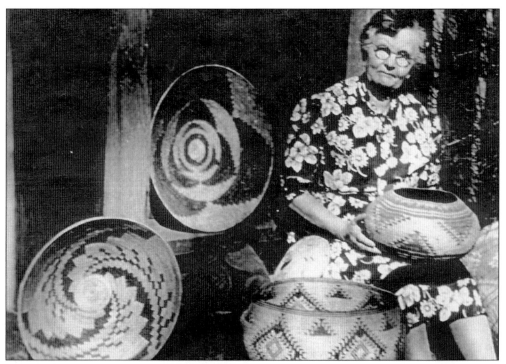

Mary Belle Davidson was the founder and the first curator of the Lake County Museum. Shown here with some of the Pomo baskets in the museum collection, she worked for 15 years collecting both history and artifacts for the museum that finally became a reality in 1936. Belle took the helm as curator, a job she held for 20 years.

INTRODUCTION

Clear Lake is, and always has been, the heartbeat of Lake County. The history of this place and the people who settled here is rich with visions of a thriving community set against the backdrop of a beautiful lake surrounded by majestic mountains.

People in the international scientific community consider Clear Lake to be the oldest lake on the North American continent. The Clear Lake Basin was formed some two million years ago by the interaction of faults and volcanic activity. The basin holding the waters of Clear Lake developed from these forces and even today continues to adjust to geological pressures. In 1973, John Sims, David Adams, and Mike Rymer of Stanford University, working under the auspices of the U.S. Geological Survey, provided documentation that bolsters this theory. They took numerous core samples of the lakebed, revealing a complex geologic history. Though they extended their coring equipment to its maximum, they never reached bedrock. From the information they gathered, however, they were able to reconstruct a nearly continuous sedimentary record of the past 450,000 years.

Lake County also claims some of the earliest archaeological evidence of human habitation in California. Investigations show that for 12,000 years the county has been home to one of the state's most densely clustered native populations. The Pomo flourished in the temperate climate with an abundant food supply of plants and wildlife on land and in the water.

The first non-aboriginals to arrive were likely trappers who recognized an area of vast beauty and wealth. Native Alaskan hunters, called *Aleuts* by their Russian employers, made their way here from their California outpost at Fort Ross in their quest for furs and pelts. By 1831, trappers had returned to the fort with stories of a big lake. Two years later, even the Hudson Bay Company reached Lake County. Records show John Work and a party of 163 trappers made camp near what is today the city of Lower Lake.

In the early 1850s, most of what was to be designated Lake County was being grazed by large herds of livestock. Thousands of long-horned cattle wandered freely in the hills and valleys, having been abandoned by Mexican general Mariano Vallejo when he left his once-extensive rancho. Settlement accelerated in the mid-1850s. Covered wagons from Missouri and elsewhere crossed the plains and made their way to the Sacramento Valley, then through the Napa Valley, and into Big Valley. The journey from Napa Valley to Big Valley took 12 difficult days. The mountains were steep and brushy, nearly impenetrable to horses or wagons. Woods Crawford, who arrived with a party led by Martin Hammack in 1854, tells of having to hand-winch wagons slowly and painfully down the hillsides into the county. He stated that those last few days were the most difficult of the entire trip.

By 1859, there was a small settlement of new arrivals. It was called Forbestown, after Williams Forbes, a wagon master and undertaker who had claimed 160 acres on the western lakeshore. In 1861, Lake County was officially created from the northern portion of Napa County and small pieces of Sonoma, Mendocino, and Colusa Counties. It began with three distinct precincts: Forbestown, Upper Lake, and Lower Lake. Forbestown was changed to Lakeport at the suggestion of Woods Crawford, who had become the first postmaster. Lakeport was selected by popular vote as the first county seat, and a wooden courthouse was completed in 1861.

More people arrived. In 1870, there were 500 votes cast at the courthouse election booths. By the 1890s, the number had tripled. Tourism also began in the 1870s, and Lake County's mineral springs became widely known for their medicinal qualities. The selection of the names Nice and Lucerne for communities on the north shore was meant to remind visitors of the similarities between Lake County and Switzerland. Mining, logging, farming, and tourism were the major forces in the county's young economy.

The expansion and improvement of the highway system in California made it easier to reach other northern California resort areas, such as Lake Tahoe. However, state funds were slow to arrive in Lake County. Mountain roads remained unpaved, dusty in the summer, muddy quagmires

or snow-bound in winter. Activity at the bigger resort hotel complexes waned and shifted to the development of small inns, and after the advent of the automobile, motels along the lakeshore. Tourism went through major transformations, but people continued to come to the county to enjoy swimming in the lake, boat races, fishing, big-band music at Hoberg's Resort on Cobb Mountain, and just plain fun. Lake County continues to be a remarkable setting for both its growing population and vacationers.

The courthouse square has long been the Lake County welcome center.

One

Clear Lake Basin Beginnings

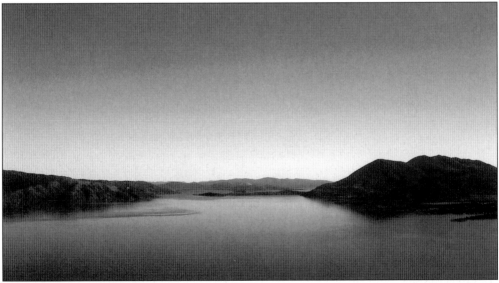

More than three million years ago, the San Andreas Fault started spreading northward. When it reached the latitude of Clear Lake, other faults developed: Konocti Bay fault, Main Basin fault, and Big Valley fault. These faults, plus the action of the Clear Lake Volcanic Field, formed the basin. Today Clear Lake consists of three distinct basins, the largest being the Main Basin, covering 110 square kilometers, with the Highlands Arm and Oaks Arm much newer and smaller. The shape and size of the lake has changed through the years, adjusting to shifts along the fault lines. Even though numerous creeks carry sediment from the mountains into the basin, the lakebed has not filled and transformed into a vast meadowland because the bottom of the lake continues to shift downward at the Main Basin fault along the northern shore.

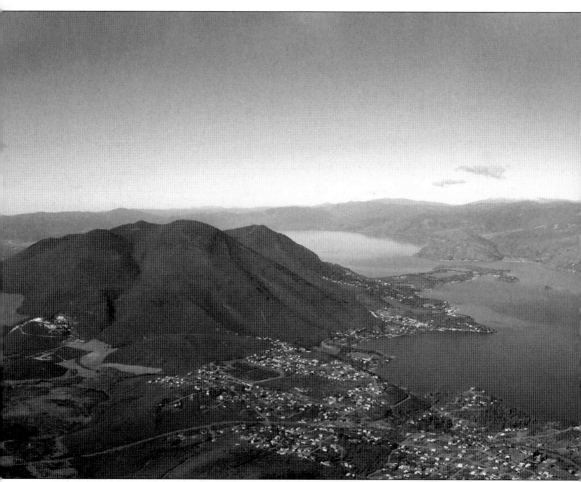

Significant volcanic activity began here around two million years ago as part of the northern progression of volcanism throughout a region that extends from Lake Berryessa in Napa County to Clear Lake. One of the most important eruptive episodes occurred some 450,000 years ago with the formation of Mount Konocti. Volcanic activity continued until approximately 10,000 years ago. This photograph shows the massive mountain partially hiding the main basin of the lake, which is visible in the center. Buckingham Peninsula spreads northward forming "the Narrows," a passage between the main basin and the two arms of the lake. Both the Highlands Arm and the Oaks Arm continue to the right of the picture.

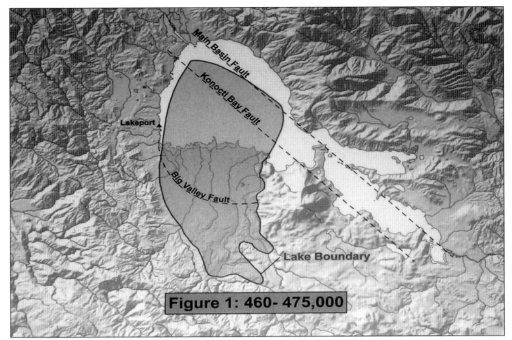

This map shows the lake as it was approximately one-half million years ago. The lake had a north/south orientation and completely covered Big Valley. The three major faults are in place, controlling the development of the lake.

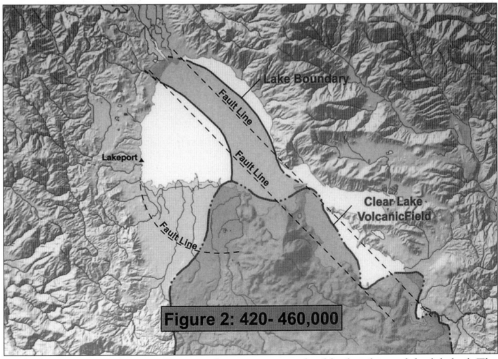

With the formation of Mount Konocti, there was a considerable shrinking of the lakebed. The large land mass this is now know as Big Valley shifted and rose above water level.

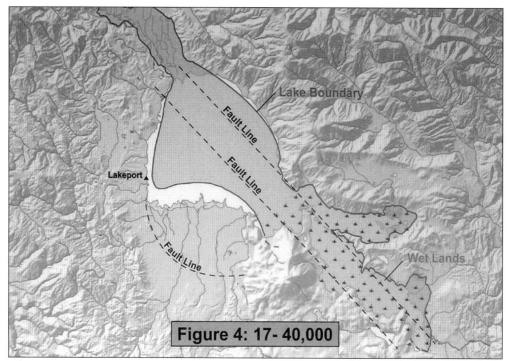

About 40,000 years ago, wetlands appeared in the southeastern section of the Clear Lake basin. Over the next 30,000 years, the water level rose and the marshes filled, once more expanding the size of Clear Lake.

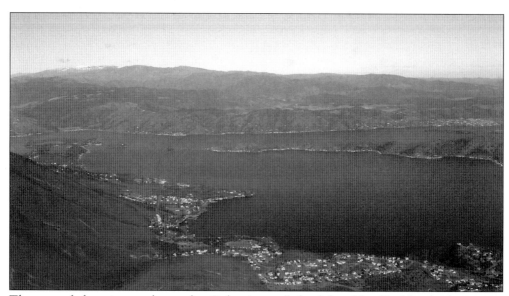

The top of the picture shows the Oaks Arm of the lake. The Highlands Arm is in the foreground.

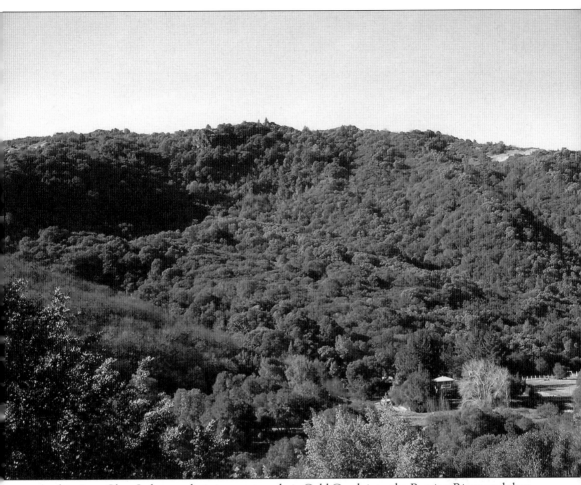

At this time, Clear Lake was draining westward via Cold Creek into the Russian River, and then on to the Pacific Ocean. Approximately 11,000 years ago, a massive landslide took place across what is today Highway 20 at the present Lake and Mendocino County line. The highway climbs up and over this slide just on the west side of Blue Lakes. The scarring effects can easily be seen to the south of the road. A second slide occurred sometime later and these two events blocked the Cold Creek Canyon. The trapped water rose, and Blue Lakes formed in the flooded canyon. Streams within the watershed continued to pour into the Clear Lake Basin. Finally the water overflowed into the Cache Creek outlet. Clear Lake now drains eastward through the Cache Creek Canyon into the Sacramento River and on to the Pacific Ocean.

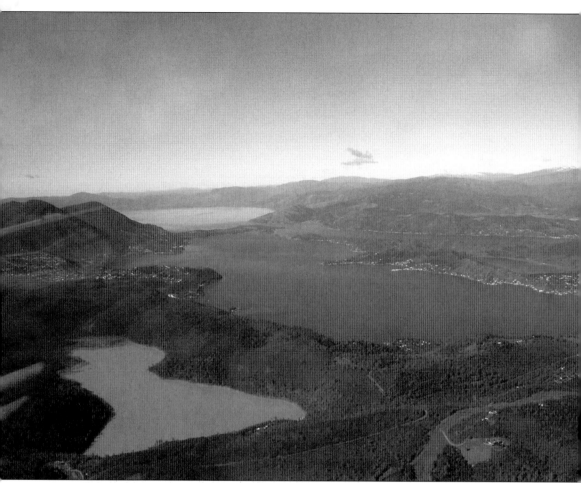

Today Clear Lake is the largest natural freshwater lake entirely within the boundaries of California. It has a surface area of 40,000 acres and a storage capacity of 420,000 acre feet. The drainage basin is an immense 492 square miles. The watershed to lake surface ratio is 12 to 1, while Lake Tahoe's ratio is 6 to 1 and the Great Lakes are 3 to 1. The total length of the lake is 19 miles, and the greatest width (north/south) is approximately 7 miles. Circling its shores is 108 miles of highway. Today the Cache Creek Dam artificially maintains the lake level at an elevation of 1,328 feet.

Two

First Settlement

This view shows archaeological excavations during the summer of 1938 at Borax Lake. Funded by a grant from the Carnegie Institution in Washington, D.C. with additional aid from the Southwest Museum of Los Angeles, this was only the beginning of archaeological research in Lake County. California archaeologists have established that people began moving up the area now known as Cache Creek 12,000 years ago. These people (Proto-Pomo) were moving west and slowly making their way up the canyons and creeks to an area now called Anderson Marsh. This marsh has the distinction of being one of the most densely populated areas in prehistoric California. Twenty-seven Native American sites have been discovered inside the boundaries of the Anderson Marsh Historic State Park. The time span of occupation ranges over 10,000 years. The southern Clear Lake basin contains the longest cultural sequence of any area in the North Coast Range. The people continued moving north to what is now the Oaks Arm of the lake. These sites were the first settlements here of people we now call Pomo.

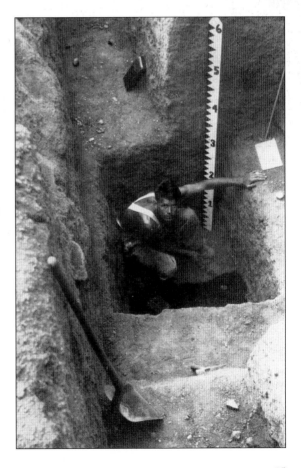

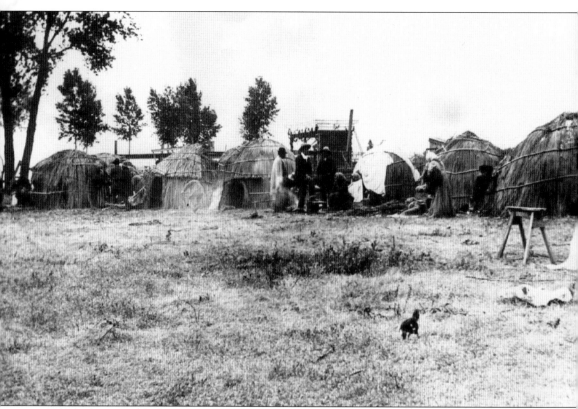

This demonstration Pomo village was erected along the Lakeport waterfront in 1896 as part of the annual Lakeport Regatta. The Pomo divided into small groups, often called villages or tribelets. Their villages were made up of a variety of structures that were adapted to the seasons. The lake was bounded by enormous stretches of tule beds. Winter homes were large multifamily dwellings constructed with a framework of bent poles covered with gathered tule mats or bundles. These circular or oval family homes could reach 30 feet in length and house a large extended family. Family groups had their own entrance doors and fires, but would share the food-storage facilities for surplus acorns and other foods.

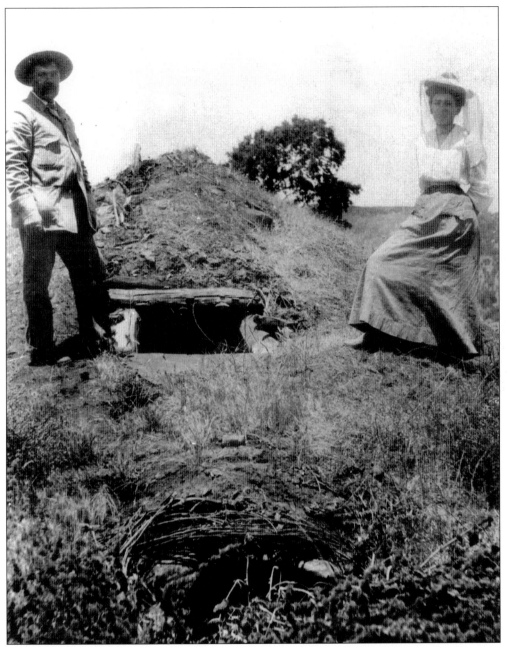

Each village had both a subterranean ceremonial house and a true sweathouse. Sweathouses could be up to 20 feet in diameter. They functioned as men's clubs. After the men had completed their ceremonial sweats, they would often stay and sleep there, leaving the women and children in their tule homes. Ceremonial structures were also located in the villages. These structures were the largest of all, reaching up to 60 feet in diameter. Constructed as semi-subterranean earth lodges, they often appeared as a sloping hill with smoke emanating out of the top. One large pole stood at the center and was surrounded by eight smaller poles, evenly placed. A large fire pit was placed between the center pole and the south entrance that was built like a tunnel. Here dances and other ceremonial rituals were performed.

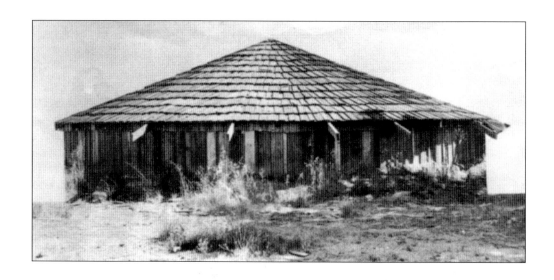

As time passed and different building materials became available, shingles were used for the roof instead of sod. Wide planks replaced the upper portion of the earthen walls. The building profile remained low, however, as the Pomo continued the tradition of excavating a large circle to create the earthen dance floor. Pictured above is the dance house at the Big Valley Rancheria. Below is the dance house constructed near Middletown.

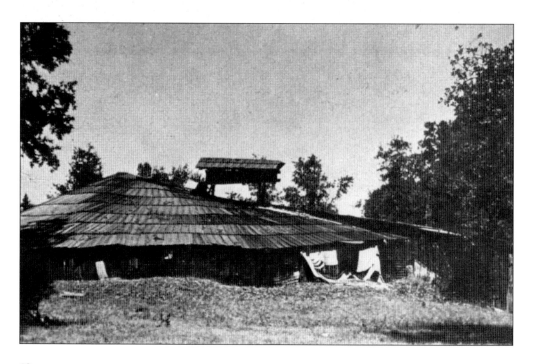

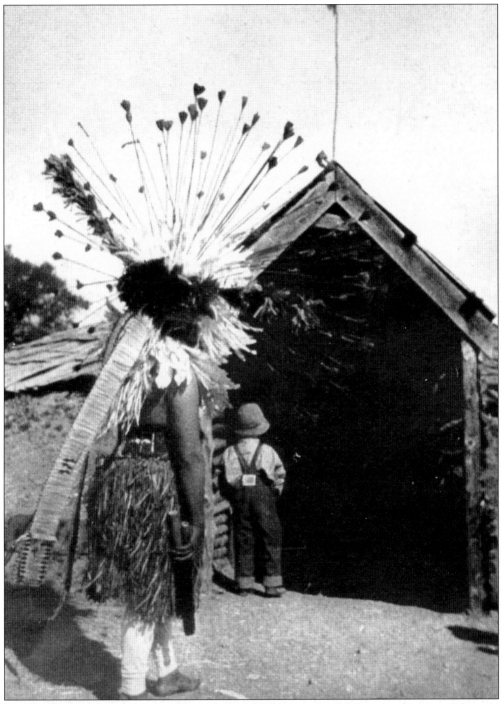
The Big Head dancer pauses in front of the Middletown dance house, and a young observer watches the activity inside.

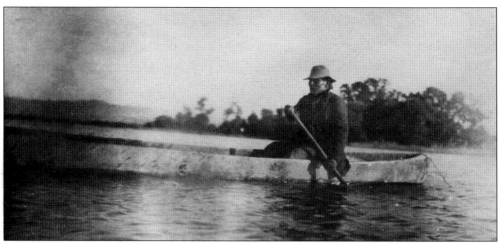

In this undated view, a Pomo man paddles his dugout on Clear Lake. For 4,000 years, the Pomo continued to live, fish, trade, hunt, and gather in relative quiet, a steady and uninterrupted presence. By 7,500 years ago, the Pomo were clearly established, and thanks to the richness of their environment, they found their numbers increasing. This population growth prompted expansion. Some people migrated around the lake's shoreline and into new areas such as Big Valley. This was the beginning of territory and tribal boundaries.

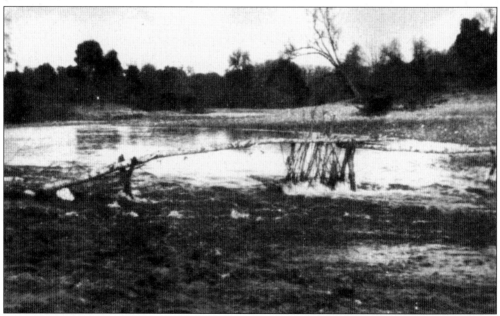

One method the Pomo devised to capture fish was this weir, set up in a small cove along the lakeshore. Weirs, or dams, were usually made by driving posts into the bed of the lake or a creek and then tying on horizontal poles, to which large amounts of brush were attached to form the dam. Basketry traps were often used in conjunction with weirs to catch fish.

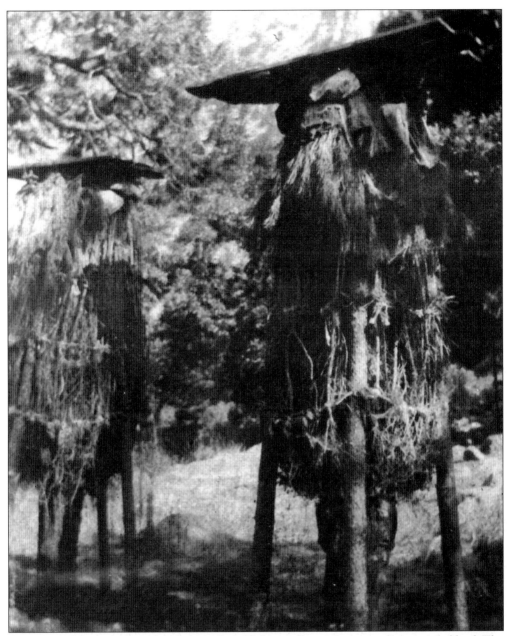

Varmints, birds, and insects have always been a plague when it comes to the storage of food. The Pomo developed ingenious ways to thwart these creatures. The view above shows an excellent example of raised acorn storage. Using such techniques, the Pomo continued to be successful in a land rich with both plants and animal life. Food gathering was timed to the seasons. Suckers, native carp, hitch, and blackfish were caught in masses, then dried, stored, or traded during the rest of the year. The gathering of acorns, five different types, took place in late fall. The same was true with different seeds, grains, nuts, and buckeyes that were stored and eaten year-round. While the daily diet of most people consisted of dried fish and acorn mush, these foods were easily supplemented with fresh meat (deer, rabbits, quail, waterfowl, and shellfish), fresh summer greens, and with berries and fruits in season.

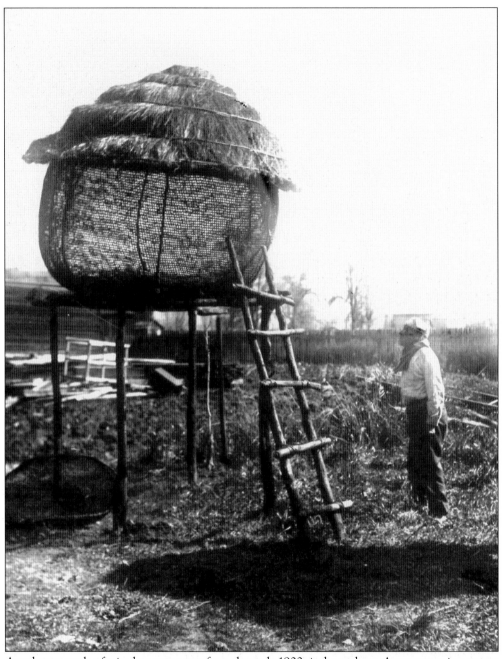
Another example of raised acorn storage from the early 1900s is shown here. Acorns were important to the Pomo throughout the year. Effective storage during the winter months was essential.

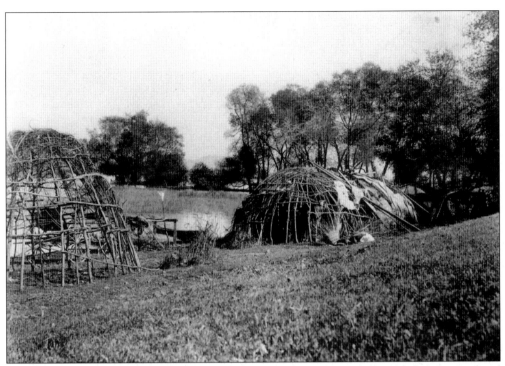

The photograph above shows a wicker pole framework for tule homes, and below, a completed tule house. Tule was an abundant natural material. It was used for shelters and homes, buoyant and speedy boats, clothing such as skirts and mantels, mats for seating and covers, and even tule moccasins. It was shredded for use as diapers, padding, and soft beds. Both Pomo men and women wore ear ornaments of wood, bird bone, and feathers. Rabbit skins were woven into blankets. They were worn as capes and used as bed covers.

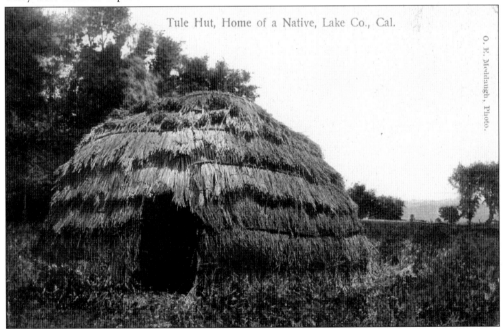

The Southeastern Pomo were mainly island dwellers, settling Anderson Island, Rattlesnake Island, and Lower Lake Island. The Eastern Pomo preferred living away from the lakeshore, and settled along creeks and streams, such as Kelsey Creek, Manning Creek, Middle Creek, and Clover Creek. Geographical names were given to these American Indians by anthropologist S. A. Barrett, who in 1908 recognized that the Pomo language was really a complex of seven distinct languages, each one differing as much as English does from German. He used geographic boundaries to distinguish the seven distinct speech families: the Southwestern Pomo, Southern Pomo, Central Pomo, Northern Pomo, Northeastern Pomo, Eastern Pomo, and Southeastern Pomo. Small populations of other American Indian groups also lived in this area, the Lake Miwok and the Wappo.

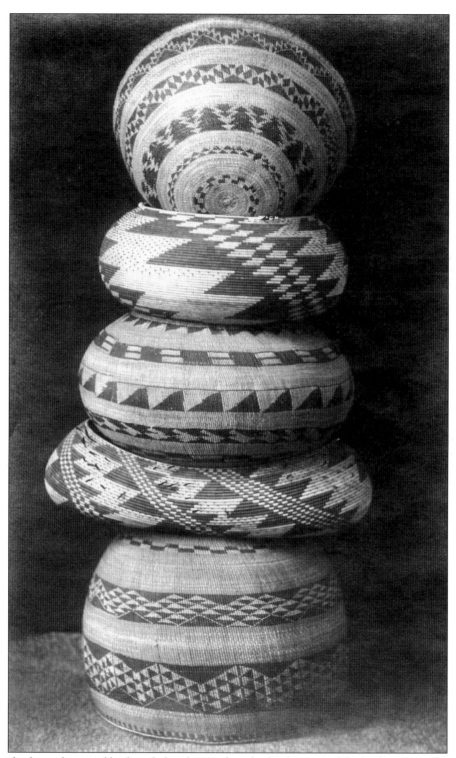
Pomo basketmakers used both coiled and twined methods of weaving. The baskets at top, bottom, and center are twined; the other two are coiled on a rod foundation.

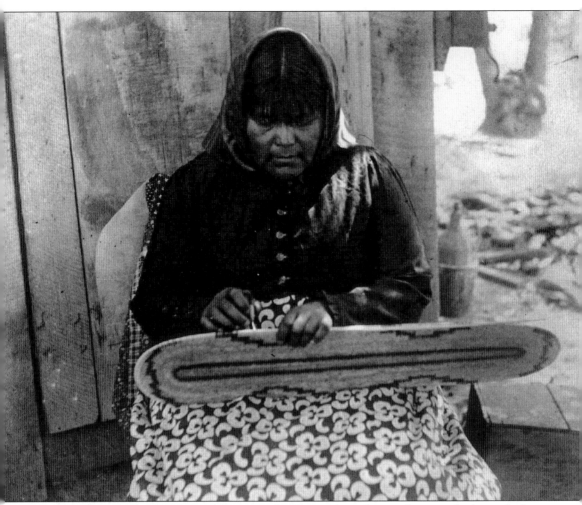

This photograph of Lucy Jones, Scotts Valley Pomo, shows her working on the base of a large, coiled "canoe" basket. The Pomo were extremely inventive with natural plant materials in their unique baskets. They were used for every part of daily life: gathering acorns, nuts, and berries; and trapping all sorts of fish, birds, squirrels, and rabbits. Using baskets woven tightly enough to hold water, women added hot stones to heat and cook the contents. While baskets were utilitarian, they were also an expression of art and skill. Pomo were known to weave 80 to 100 stitches to an inch. Intricate designs were sometimes further detailed with assorted colored feathers, including red from the woodpecker, yellow from the meadowlark, blue-green from mallard ducks, orange from the oriole, and the black topknot of quail. Clamshell disks and abalone shell pendants further enhanced their beauty. Most women learned the time-consuming process of weaving from their mothers. The correct materials had to be collected, then dried, prepared, and sized—even before the task of weaving could begin. Many baskets took several months or even years to complete.

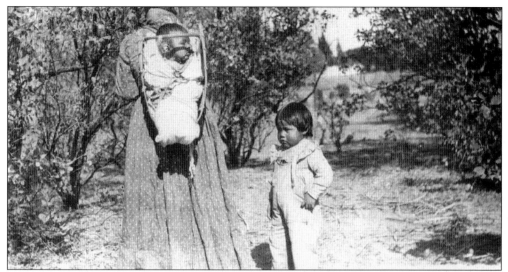

Babies were placed in basket carriers soon after their birth. These pictures illustrate the ability of the mothers to carry their children with them at all times and still have their hands freed for other work.

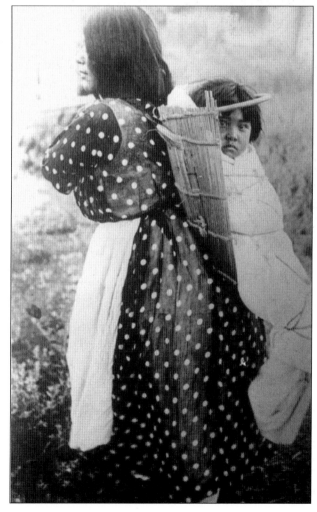

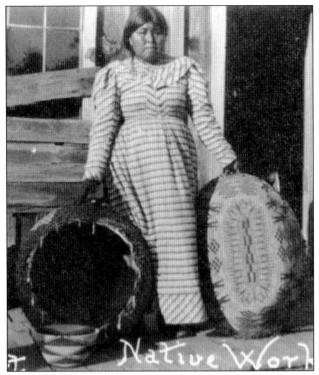

In this photograph, Polly Homes displays her use of feathers and clamshell bead decoration on the large round basket. The human figures woven into the large oval basket at right were a departure from traditional designs.

Pomo/Patwin Mabel MacKay of Lake County demonstrated how to weave in quail topknot feathers at the Citrus Fair in Cloverdale in 1964.

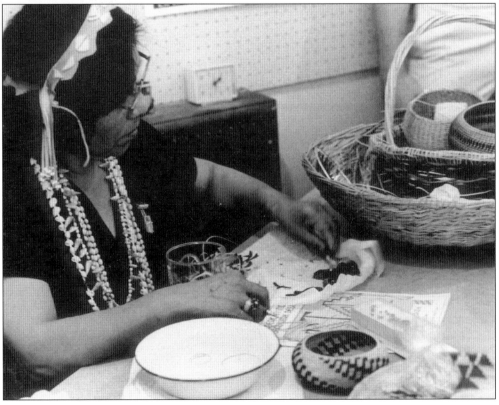

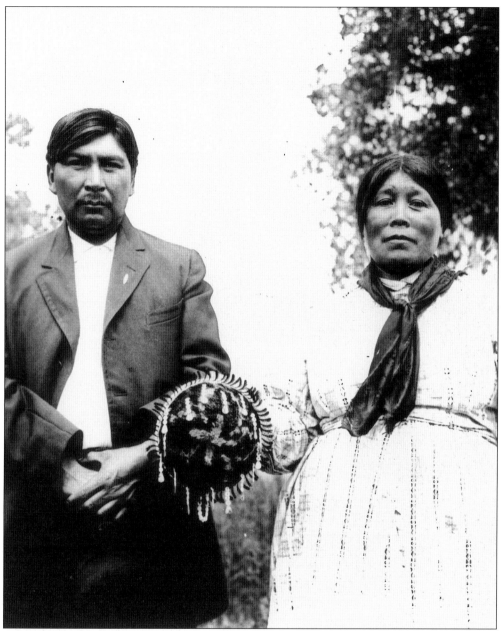

This unidentified couple may have worked together to gather the materials for the ceremonial basket shown in this photograph, he snaring the birds for the feathers she included in her design. The first-known written account of the quality of basket making in California was recorded during Englishman Sir Francis Drake's 1579 expedition to the California coast. Probably a Pomo ceremonial basket, it was said to be "like a deep boat, and so well wrought as to hold Water. They hand [sic] pieces of Pearl shells, and sometimes Links of these Chains on the Brims, to signify they were only used in the Worship of their Gods: they are wrought with matted down of red feathers into various Forms."

Starting in the 1830s, the Pomo lifestyle began to change drastically. In 1833, a "pandemic" struck areas north of San Francisco. While never satisfactorily identified, it could have been measles. This was followed in 1837 by a smallpox epidemic that spread from the Russian settlement at Fort Ross. Starting along the coast, the disease moved northward, eastward, and finally up the Russian River to Clear Lake. It probably wiped out at least a quarter of the Pomo population, and was a harbinger of things to come. Diseases combined with deadly conflicts with "invaders" including Salvador Vallejo, the Mexican Army, enslavement by early American settlers Stone and Kelsey, followed by the punitive expedition of the United States Army, devastated the Pomo population. Such a decline in a society that was so delicately balanced with its natural surroundings meant the end to their quiet and peaceful life in Lake County.

Three

NEW ARRIVALS

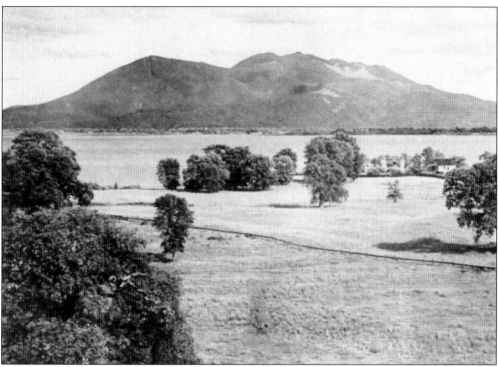

Even before the discovery of gold in California, people in the eastern part of the United States had become aware of a large lake surrounded by mountains in northern California's coast range. As the gold fever subsided, those who had come west with families began looking for other means by which to prosper. Many returned to more familiar pursuits: farming, ranching, and commerce. Perhaps the wide, tule-bordered lake suggested abundant rainfall, such as they had known in the east. Rolling hills and broad valleys beckoned. In 1854, a wagon road was carved over the mountains from Napa City through the chaparral- and pine-covered hills to Clear Lake. Within a decade, most of the best valley land was claimed and occupied. However, throughout these early years, the area remained an "interior frontier" where settlers were dependent on subsistence farming and on a small cash income from sales of livestock and grain. The first white family was likely that of Walter Anderson. He arrived in 1848 with his wife and stepbrother, Henry Beeson, in the Lower Lake area. They had crossed the plains in 1845 with the 100-wagon Grigsby-Ide Party, led by Caleb Greenwood. Greenwood had spent the winter of 1826–1827 near the present town of Lower Lake. He could have discussed the Clear Lake Basin with Anderson. Anderson and Beeson built a cabin just southwest of Cache Creek on what was known as the Guenoc grant. Their land was awarded to them in 1845 by Pio Pico, then Mexican governor of California. The Anderson ranch was used as headquarters by the American army that was sent to search out the Indians in 1850. In the fall of 1851, Anderson moved west of Ukiah to a valley that still bears his name.

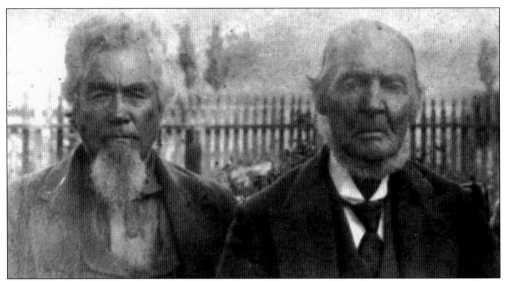

Henry Beeson, left, and Benjamin Dewell went to General Vallejo's headquarters in Sonoma to secure their land grants. The Guenoc grant was six square leagues, 21,220 acres, stretching from Coyote Valley almost to Lower Lake. Dewell chose a land grant in the northwestern section of the basin that became the Upper Lake district. Born in Ohio in 1823, he moved with his parents to Indiana in 1840. Five years later, he left with a small group of adventurers. Near Independence, Missouri, he joined the wagon train that included the family of W. B. Elliott. Several from this group settled in the Napa Valley near Calistoga. In the spring of 1846, Dewell and Elliott were among the group that joined the Bear Flag Rebellion and commandeered the mission fort at Sonoma. They took down the Mexican flag and replaced it with the "Bear Flag." Dewell, a saddler, sewed the flag from an old white wagon sheet and new red flannel contributed by Mrs. Elliott.

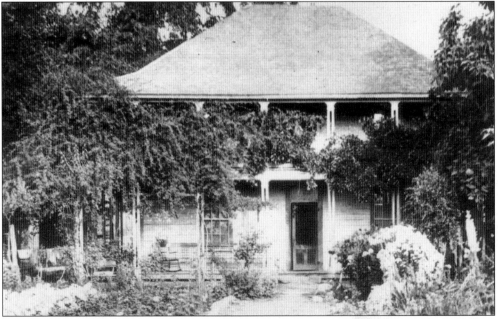

The Dewell home in Upper Lake was on Elk Mountain Road. It is said the water pressure from their artesian well was sufficient to allow water to be piped upstairs to the second story.

Cecilia Elliott Dewell, at right, her brother Thomas, and sister Jane Wilson sit in the garden in front of the Dewell home. Young Cecilia is credited with raising the Bear Flag that flew until soldiers arrived and ran up the American flag. Benjamin and Cecilia were married four years later, and in 1854 both families moved to the Upper Lake area.

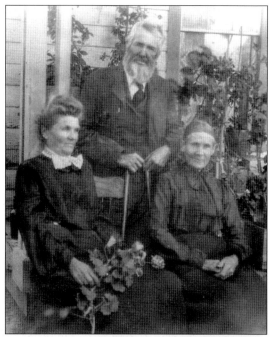

Teams of oxen pulled W. B. Elliott's wagons across the plains. Once his family was settled near Calistoga, Elliott put the teams to work in a lumber mill.

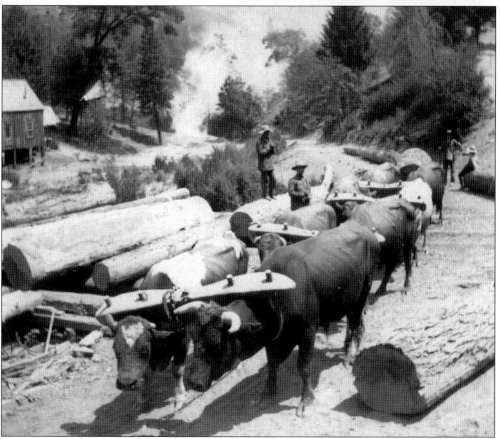

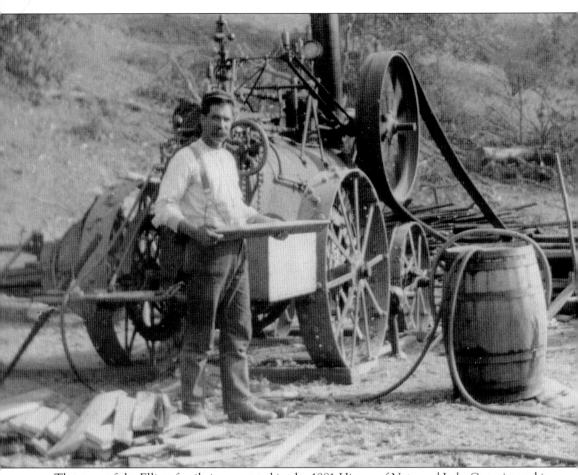

The story of the Elliott family is recounted in the 1881 *History of Napa and Lake Counties* and is similar to that of many of the families who settled here. Born in North Carolina in 1798, Elliott married Eliza Palton in 1821, and they lived in Virginia until 1833. He moved his family to Missouri for a few years, "little dreaming he would push on in the vanguard of pioneers toward the sunset until he found a home within sound of the waves of the Pacific." Twelve years later, they left with a large company bound for Oregon. "Mr. Elliott had with him a wife and seven children. At Fort Hall (Idaho) the party divided, part going to Oregon and part to California . . . by way of Donner Lake to Sutter's Fort, and on to Younts (now Yountville) near Napa. On the plains, Elliott was a leader. He did not know the meaning of the word fear. In the spring of 1846 he was at work with his ox-teams, hauling lumber from Smith's Mill to Bodega Bay. . . . He became noted as a great bear hunter, and with his boys probably killed more grizzlies than any other man in the state." It was on one of these hunts that Elliott and one of his sons "noticed a strong smell of sulphur, which surprised them, and they determined to solve the mystery. As they went down the stream, the smell of brimstone, to use the old man's words, increased, and they were still further amazed by coming in sight of a cloud of steam which seemed to rise from the bottomless pit itself." They had seen "the Geysers" and the beauty of Lake County. Elliott also saw land that was suitable for cultivation. In the fall of 1854, at age 56, Elliott and his son-in-law, Dewell, moved their families to the land Dewell had been granted many years earlier. Elliott's son Thomas, shown above, moved into the mountains north of Upper Lake. He hauled in the heavy equipment needed to process timber, and developed a lumber mill at Lower Buck Ridge on Bartlett Mountain.

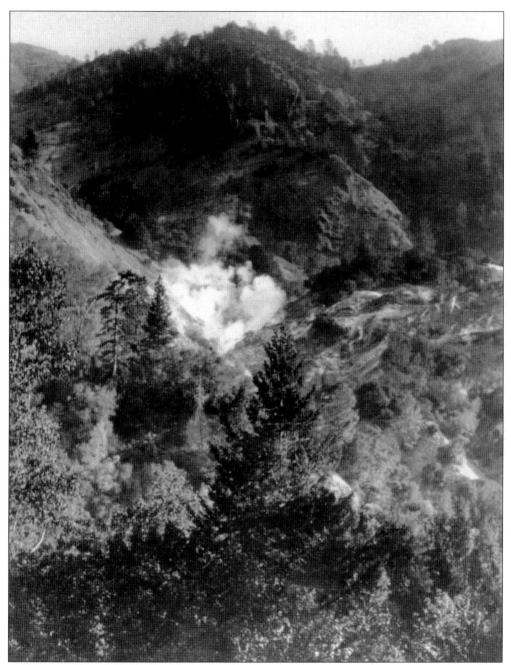

"The Geysers" straddle the Lake and Sonoma County line. The layer of magma that underlies an extensive section of both counties is close to the surface and creates conditions necessary for geothermal activity, including geysers of hot water and steam shooting up from the ground. A large, two-story hotel with side verandas, mineral baths, and trails for hiking to the geysers and to fish in the mountain streams enticed visitors to the area. The names of notables such as Pres. Ulysses S. Grant and Gov. Leland Stanford are in the guest register. More recently, the development and production of geothermal energy has become the primary activity in this area. The electricity produced here is routed through much of northern California.

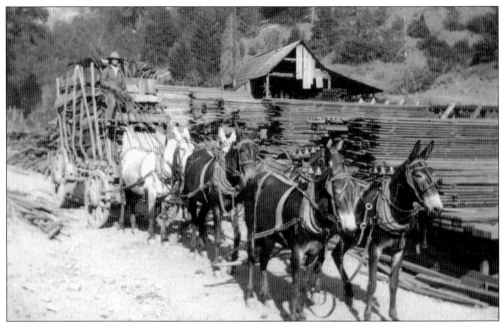

Elliott's Buck Ridge Mill was one of many in Lake County. Demand for lumber to build homes, barns, corrals, and businesses was high. Firewood was needed not only for heating and cooking, but also to fuel the furnaces making charcoal for the smelters at various mines. The long-horned cattle pastured by General Vallejo in Big Valley possessed a natural defense against the mountain lion and grizzly bear that populated the mountains surrounding Clear Lake. However, the short-horned cattle brought across the plains by later immigrants did not fair so well, nor did other domestic animals. Below, marksmen like Madison Elliott, another of W. B. Elliot's sons, did their best to lessen the threat.

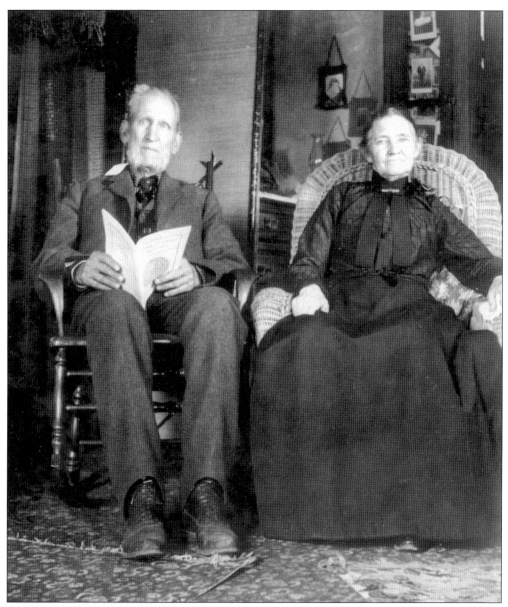

Woods Crawford and his wife, Margaret Ann, enjoy a quiet moment in the living room of their home in Lakeport. Crawford was born in Richland County, Ohio, in 1829. At age nine, his family moved to DeKalb County, Illinois. He began teaching vocal music when he was 18. In 1850, he moved to Missouri, where he taught music for three years, then switched to carpentry. He met Margaret Ann Hammack, and they were married in 1853 just before starting across the plains. They made the long journey westward with a group known as the "Hammack Party," traveling in wagons and driving a herd of cattle. The Kentucky long rifle used by Crawford on the journey is in the Lake County Museum. The families lived in Shasta County for one winter, then came to Lake County in 1854, settling in Big Valley near Kelseyville. The Crawfords moved to Lakeport in 1864, where Woods was appointed postmaster, opened a law office, and was elected district attorney. Appointed by the state legislature in 1861, he served on the commission to create Lake County.

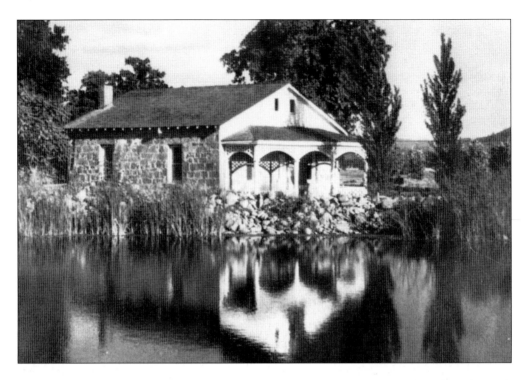

In 1853, Capt. R. Steele and Robert Sterling began building this stone house beside Putah Creek on the Guenoc land grant. In 1851, L. W. Parkerson and C. N. Copsey built a cabin just outside the present town of Lower Lake. Copsey's six sons worked with their father in Jericho Valley, raising grains for stock feed. A short while later, Copsey opened the Helen Mine near Middletown. One of the Copsey brothers is pictured below emerging from the mine tunnel with a car of cinnabar ore. Numerous families now living in Lake County are descendants of this second wave of immigrants who, like the first, found the Clear Lake basin an ideal place to call home.

Four
Mountains and Springs

This vintage postcard shows the view across Borax Lake toward Buckingham Point. The gradual breakdown of isolation on the "interior frontier" came with the growth of economic activities associated with the gold rush. The worldwide popularity of mineral water for the relief of myriad physical ailments was a second major factor. In 1864, the first borax produced in the United States was extracted from a deposit on the east side of the lake at the site named, appropriately, Borax Lake. Sulfur mining began at Sulphur Bank Mine near present-day Clear Lake Oaks one year later. A tenth of California's quicksilver (mercury), much in demand in the gold- and silver-mining areas of the West, was produced in Lake County. Greene Bartlett discovered hot springs in the mountains north of Clear Lake in 1870, setting the stage for another major commercial development. Three years later, writer and salesman L. L. Paulson made a trip from San Francisco. His goal was to produce *The Handbook and Directory of the Pacific Coast*. He made a complete circuit around the lake, recording his adventures and travels while selling advertising. The book was a boon to Lake County tourism. "The day is near at hand," said Paulson, "when the shrill whistle of the locomotive will be heard on the shores of Clear Lake. Then a great future will dawn for Lake County; her valleys will be dotted with numerous villages, her towns become beautiful cities, and her mines bring forth the hidden treasures of the earth. The mineral springs will be the renowned spas of the western world, visited by thousands of invalids from all climes, and the waters will be exported to the four quarters of the globe, to be used by those who cannot come to the source. Pleasure seekers who usually spend the winter in Italy and the summer in the Pyrenees, will come here to admire the beauties of a country but yesterday a wilderness, today inhabited by a thrifty, orderly and intelligent community."

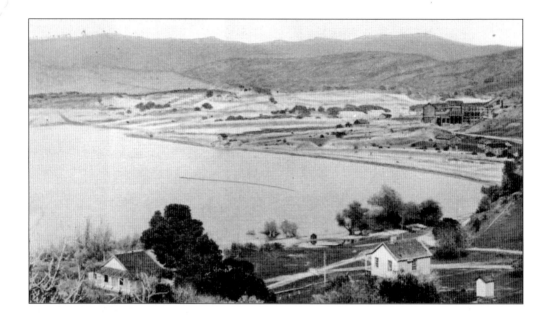

The buildings in the foreground of this image are the houses and outbuildings for the superintendent of the Sulphur Bank Mine. The site where ore was being extracted, shown below, is across the bay. Sulphur Bank Quicksilver Mine was a 120-acre site owned, initially, by John Parrott, Tiburcio Parrott, W. F. Babcock, D. O. Mills of Sacramento, and the William Burling's estate. From 1865 to 1871, it was mined for sulfur. Beginning in 1872, mercury ore was mined from underground shafts. During the first two years of quicksilver mining and smelting, a total of 12,341 flasks of mercury were produced and sold. The company treasury recorded more than $600,000 income. Mining ceased in 1905, but between 1915 and 1957, open-pit mining occurred periodically.

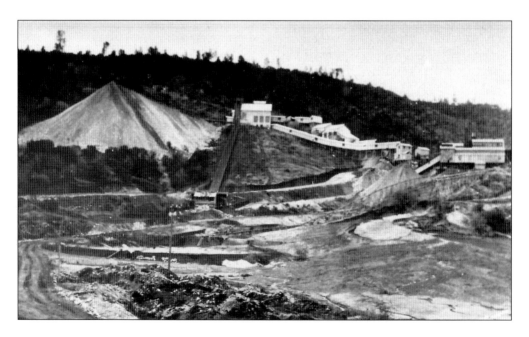

NAPA, LAKE, SONOMA AND MENDOCINO COUNTIES.

Great Western Quicksilver Mining Company.

INCORPORATED AUGUST 8, 1872.

Location, Lake County, Cal.

TITLE, UNITED STATES PATENT.

CAPITAL STOCK, $5,000,000. - - - - - - 50,000 SHARES.

Office, 312 Montgomery Street, San Francisco.

OFFICERS:

E. GREEN, President. MERCHANTS' EXCHANGE BANK, Treasurer.

A. HALSEY, Secretary. E. GREEN, Superintendent.

The advertisement for the Great Western Quicksilver Mining Company appeared in L. L. Paulson's handbook. Traveler Paulson describes his arrival at the Great Western Mine in southern Lake County: "The scenery here is very picturesque, the road good, the air very pure, and we can keep up a rapid gait without fatiguing our horses, as the heat is not oppressive. The first settlement we come to is the camp of the Great Western, having a population of about 320, including 300 Chinamen. . . . The two furnaces are capable of reducing forty tons of ore per day. All the other buildings on the premises are new and complete in all their appointments. The mine is located in a dense growth of pine, fir, oak, and other timber that promises an abundance of time for the mine, and plentiful fuel for the furnaces, for many years to come." Much of the labor to bring ore and minerals from the earth was provided by Chinese pioneers who also sought to find a new home in the booming West. They found work in the many mines in Lake County, willing to work in an environment that sometimes proved fatal because of mercury poisoning.

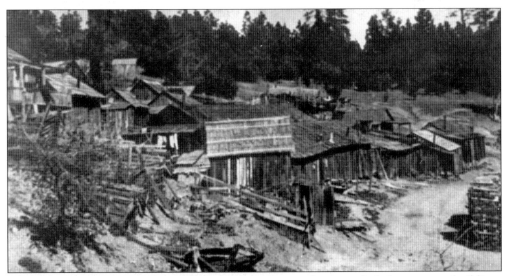

The "Chinese Camp" at Great Western Mine, shown above, included numerous buildings constructed of rough wooden planks.

Superintendent Z. W. Christopher and his wife are pictured at their home at the Mirabel Mines, c. 1892. The mines employed a great many people. Some became small communities that included barracks for workers, homes for families, stores with staples, a blacksmith shop, a post office, etc. In the photograph below, the students and teachers gather on the front steps of the Mirabel School.

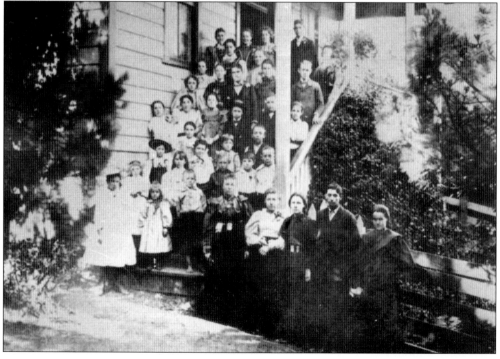

The etching above of Greene Bartlett was included in the *1881 History of Napa and Lake Counties*. In the photograph below, Bartlett stands with his wife at the signature fountain in Bartlett Springs. Born in Louisville, Kentucky, in 1835, Bartlett was still a youngster when his family moved to Hot Springs, Arkansas. In 1856, he and others brought a drove of cattle across the plains to California. Bartlett stayed in Solano County for a couple of years and then returned east via Panama. He purchased another herd of cattle and brought it as far as Salt Lake City, where he sold it and continued on to California, bringing a few mules. This time he settled in the Berryessa Valley in Napa County. He did his own herding of a band of sheep but he was suffering from rheumatism. It was during a hunting and camping trip in Lake County that he happened to discover the "wonderful medicinal and healing qualities of the water in the springs." He claimed 160 acres surrounding the springs, and moved his family and herd to the high mountain valley. In frail health, Bartlett leased out some of the area near the springs and about 75 cabins of rough redwood were constructed. He gave only short-term leases. Hence, there was little incentive for the tenants to make improvements. An early guest commented that the "cabins were divided into such small rooms that when two people were in the room at the same time, one of them had to recline on the rickety bed." Down the canyon a mile or so, Samuel McMahan offered people more comfortable accommodations. He called his place Newtown. He drew people from the springs by building a store, dance hall, and skating rink. McMahan was very successful and in the late 1870s talked Bartlett into a partnership. The McMahan family bought out Bartlett a few years later. They set up the facilities to bottle water from the springs.

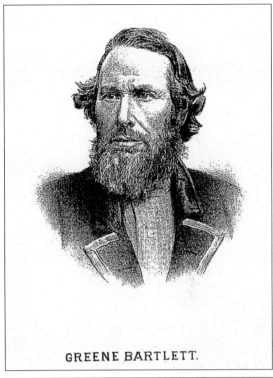

GREENE BARTLETT.

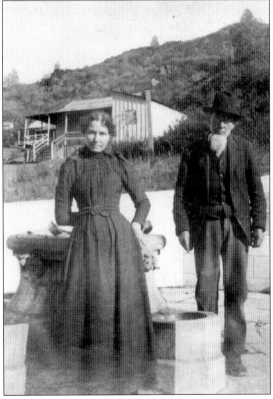

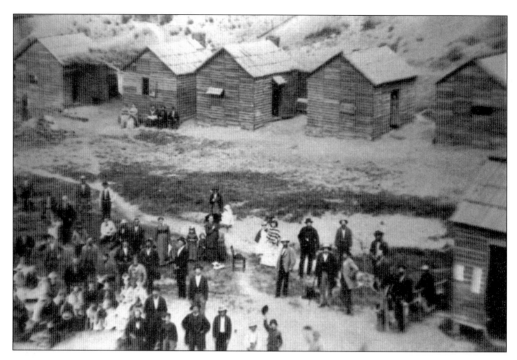

Guests at Bartlett Springs look up the hill and wave toward the photographer. People journeyed from the Sacramento Valley in stagecoaches over dirt toll roads to "take the waters." Those who came from the Bay Area could take a stagecoach like Shorty Johnson's (below) to Lakeport, and transfer themselves and their luggage aboard one of the steamers plying the lake to Bartlett's landing. Baggage would be unloaded and reloaded onto another stagecoach. The road to Bartlett Springs reaches an elevation of 3,800 feet. It was dusty in summer and often snowbound in winter.

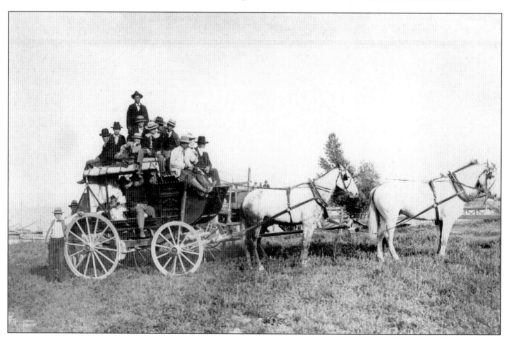

By 1916, Bartlett Springs was a thriving community. There were three large hotels, about 60 guest cabins, barracks and houses for workers, a bowling alley, general store, dance hall, croquet courts, meat market, ice cream parlor, and the bottling plant, where thousands of crates of Bartlett Water were readied for shipment around the world. In the picture below, Bud Nevins of Middletown is the driver of the team on the left. Clyde Gregory of Williams, Colusa County, is the driver on the right. They transported cargo to railheads in the Napa and Sacramento Valleys.

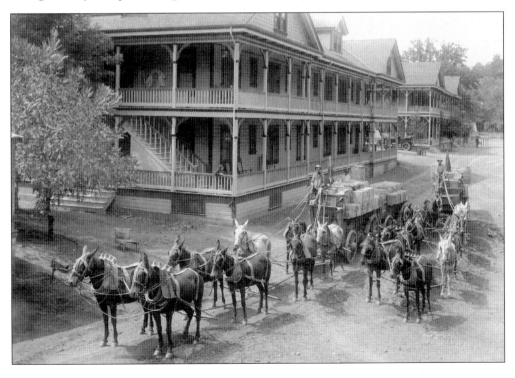

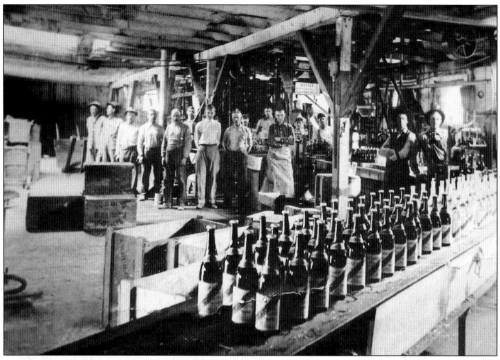

This photograph of the interior of the bottling plant was taken in 1901. The operation required numerous workers to operate the noisy equipment that transferred the water from the springs into the bottles.

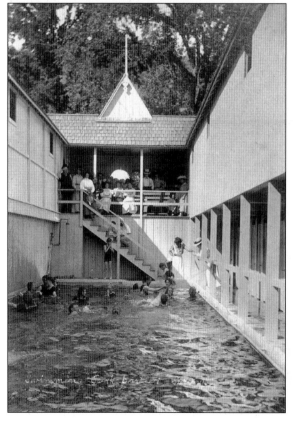

The warm spring water was piped to the swimming pool at Bartlett Springs. Dressing rooms were located adjacent to the pool for the convenience of hotel guests.

This young lad gazes in amazement at the deer being readied for butchering at the meat market. Sportsmen brought their kills to Bartlett Springs to be prepared for the trip home. By 1897, an ice plant was in operation. A large quantity of food was needed, daily, to feed several hundred guests and workers. The front porch of the meat market was a pleasant place to sit and relax. In the picture below, George Twiggs, a rancher and butcher from Upper Lake, is sitting on the left. Sitting at right is Hans Anderson, the chief engineer at Bartlett.

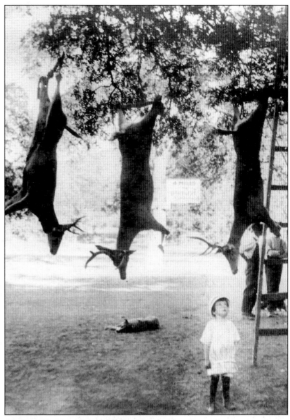

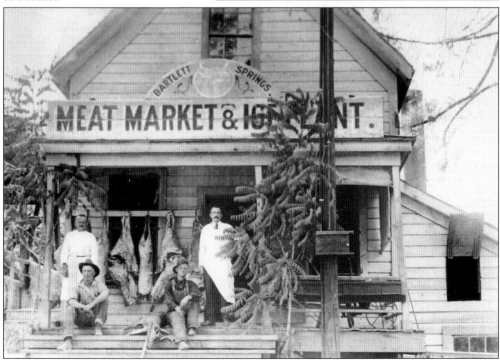

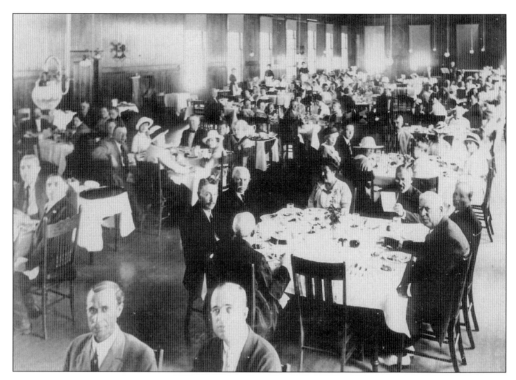

The dining room at Bartlett Springs was crowded, as shown in this 1916 photograph. Much of the food served at the hotel came from ranches and farms in Lake County. The Hanson family, who lived in Long Valley to the east, had cattle and a large dairy. They produced milk, meat, and fine cheeses. Vegetables and award-winning pears, apples, and other fruits were purchased from growers in Scotts Valley and Big Valley. In 1885, Winesap apples from the Scudamore orchard in Scotts Valley won the blue ribbon at the New Orleans World Fair. Many of the summer staff at Bartlett Springs lived in the town of Upper Lake, about 10 miles to the west. Below, waitresses arrive for their weekly shift on a summer morning. Pictured, from left to right, are Ollie Fritz, Maud Bucknell, Maud Fritz, Bertha Haynes, Winnie Tallman, Tillie Haynes, and Minnie Bucknell.

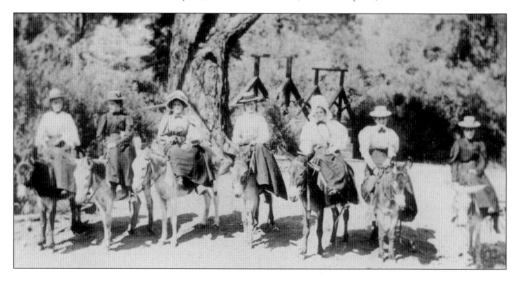

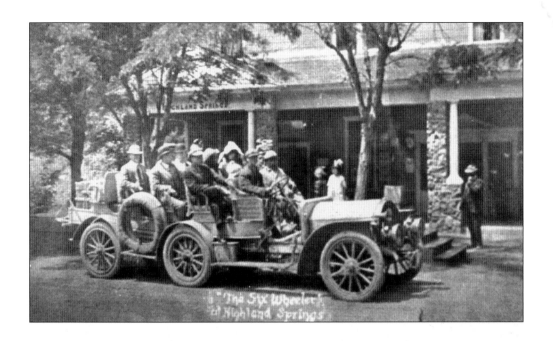

Highland Springs stood at the western gateway to Lake County. Travelers in stagecoaches, and later in motorized "stages," flocked into the county from what is now Highway 101, adjacent to the Russian River. As at other mountain resorts, tourists and locals alike gathered to partake of healthful mineral water. Guests stayed in a spacious hotel and dined in an elegant dining room. For entertainment, they would play golf, hunt and fish, stroll along the creeks, or visit the nearby towns of Lakeport, Kelseyville, and Soda Bay. A major change came in 1919 when the contract for the Hopland Grade (now Highway 175) was awarded. It was one of the last toll roads in Lake County. Of necessity, private individuals had built the initial roads in Lake County. Neither the state nor the county had the funds to do so.

The Witter Springs Hotel was just west of Upper Lake, on the road to Ukiah. It failed for a different reason. Construction began in 1905, and it was just about finished at the time of the 1906 San Francisco earthquake. The boss on the job went back to San Francisco to help remodel the Fairmont Hotel. Never a financial success, Witter Springs was torn down in 1918. Its fine wood, massive beams, and beveled windows found their way into local homes.

May Roberts, left, and her friend Evelyn Wambold stand beside a Lake County billboard, an advertising innovation that was sprouting beside new highways.

At right, Grandmother McDaniels stands beside the family's teardrop trailer. The style of family vacations changed, and with it, the type of resorts favored by visitors. Lakeside "motor courts" replaced elegant hotels. North of Lakeport, families flocked to housekeeping cabins at Rainbow Camp, pictured below. It was just a short walk across the street to the lake. The sandy beach and gentle slope of the shoreline was ideal for young children. An occasional shriek could be heard when minnows nibbled toes.

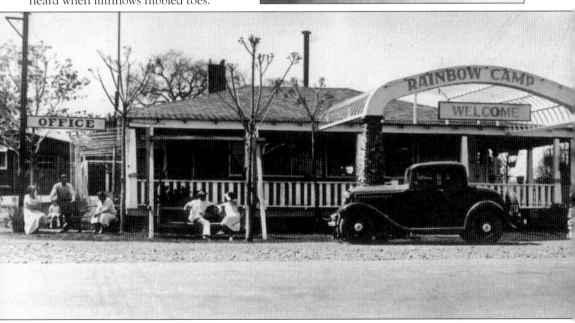

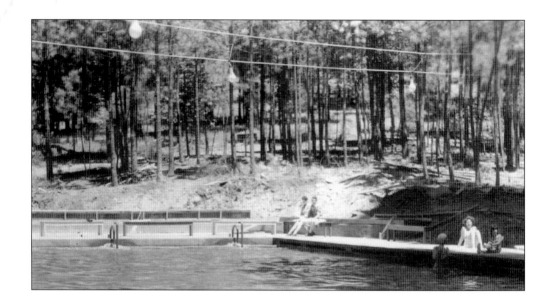

The tall pines on Cobb Mountain promised deep shade and cooler temperatures. The swimming pool at Loch Lomond, shown above, was large, and there was no need to worry about things with fins. It has been the site of swim lessons for many young people. Hoberg's Resort began as a stage stop on the Middletown to Kelseyville toll road. During the 1920s, jazz bands were booked from the Bay Area that brought hundreds of visitors to dance under the stars on their open pavilion. Its remote location was an advantage during Prohibition. Jitterbugging was hip during the 1950s, and cabins were booked all summer long, as seen below.

Five

Shore to Shore

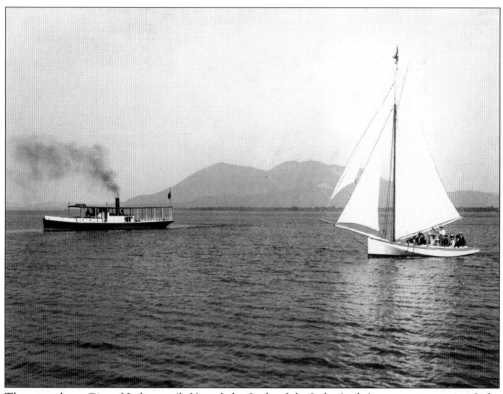

The steamboat *City of Lakeport* (left) and the *Lady of the Lake* (right) were important to Lake County's transportation system. Moving people and products was a dilemma here. Steep mountains plunged to the lake on the north shore. The high bluffs of Soda Bay and Mount Konocti blocked travel on the south shore. The county lacked the population base for sufficient taxes to build public roads, but the need remained. By the mid-1860s, several individuals built dirt roads suitable for horse and wagon traffic, and a toll was charged for their use and maintenance. The primary goal was to provide travel routes out of the county: Middletown to Calistoga, Upper Lake to Ukiah, Lakeport to Hopland, and to Colusa over Bartlett Mountain. Within the county, most lake communities were reached only by trails. The lake was the quickest, most efficient, and economical mode of transportation. While a horse and wagon team took a full day to travel from Lakeport to Lower Lake, a steamboat could make the same trip in three hours carrying 30 tons of cargo and burning cheap wood for fuel.

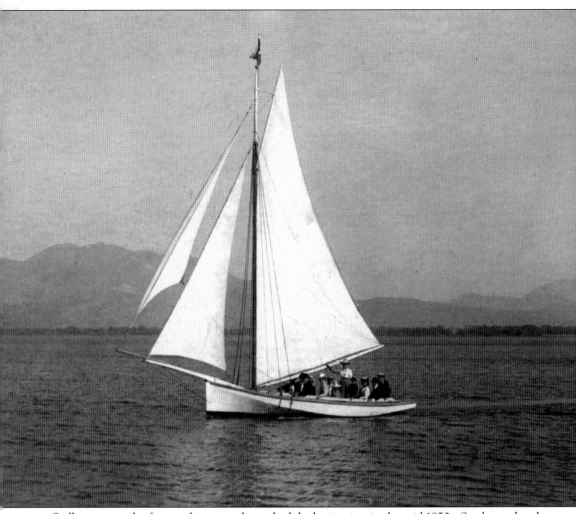

Sailboats were the first working vessels on the lake beginning in the mid-1850s. Settler and early surveyor J. Broome Smith loaded a sloop named *Plunger* onto a wagon in the Sacramento Valley and hauled it over the mountains to Clear Lake. It was only 16 feet long, but easily carried a half-ton of cargo. In 1866, another sailboat named *Lady of the Lake* began her famous 30-year service on the lake. Captain Carr of Lakeport wanted a fast sloop for general commercial use and commissioned Henry Alter to build the boat. Built primarily for hauling, she gained fame as a transporter of enthusiastic summer visitors who traveled to resort landings around the lake. Sailing vessels were kept busy shipping lumber, firewood, grain, and other important supplies from dock to dock. Major expansion occurred in 1864, when mining and freighting of borax from Borax Lake began. A year later, Sulphur Bank Mine went into operation, boosting shipping even more.

In 1873, Mrs. S. V. Chapman built the first wharf on Clear Lake, in Lakeport between Sixth and Seventh Streets, at the edge of a broad meadow. The Bartlett Springs Company soon followed suit and put in a wharf at the foot of Second Street. Another wharf at the foot of Third Street was added by Lakeport merchant Aaron Levy. Capt. Richard S. Floyd, a wealthy seaman, introduced steamers to Lake County. Floyd, a graduate of Annapolis, had sailed all over the world. His steamer, the *Hallie,* was originally a steam tender that Captain Floyd bought off the Civil War battleship *Kearsarge,* docked in San Francisco. The tender from this famous warship was brought by railway to the Napa Valley. Two specially built wagons pulled by teams of oxen were used to complete the trip. A crew of 21 men brought the tender to Calistoga and then continued over Mount St. Helena to Lower Lake. It took a full three days, due to one major crisis. When they reached the summit of St. Helena, the wagons were "upset" and dumped the tender into a ravine. She was carefully reloaded and continued on her way. On July 24, 1873, she was launched in Lower Lake, with much celebration and champagne. The steamer began her work as a freighter between Lakeport and Lower Lake. After 5 years, the steamer was sold to the Sulphur Bank Mining Company that continued to use her another 25 years. One day in 1898, she sank along the shores at Sulphur Bank. In 1908, the Yolo Power and Water Company raised her from the bottom and refitted her. The *Hallie* was used as a tug and dredge tender until 1914.

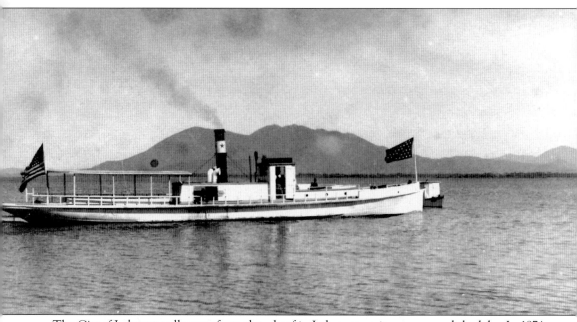

The City of Lakeport pulls away from the wharf in Lakeport on its way around the lake. In 1874, Captain Floyd, with the financial backing of the Bank of Lake, arranged for the construction of a new steamer. The City of Lakeport was built in San Francisco. Modeled after The City of Peking, at the time the finest steamer of the Pacific Mail Steamship Company of San Francisco, Floyd spared no expense. Trimmed in teak, the elegant steamer was built of Eastern oak, Clear Lake oak, and pine. Once constructed, the hull was disassembled into two pieces and hauled to Ukiah, past Blue Lakes, and on to Lakeport. When all the parts arrived, John K. Fraser, a highly regarded boat builder from Boston, reassembled her, installed the engines, and became her first captain. The City of Lakeport was 78 feet in length and 10 feet in beam. Recognized as the finest boat on the lake, she had two cabins, a pilot house, and a small afterdeck. She was a busy boat and provided a passenger service and general cargo service between Lakeport and Lower Lake.

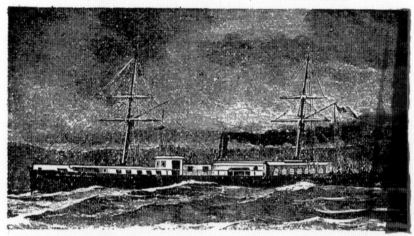

Travelers from the Bay Area rode on a variety of conveyances on their way to and from Lake County, as shown in this advertisement from a San Francisco newspaper. For $6, a person could take a route that included rail, stage, and steamer travel.

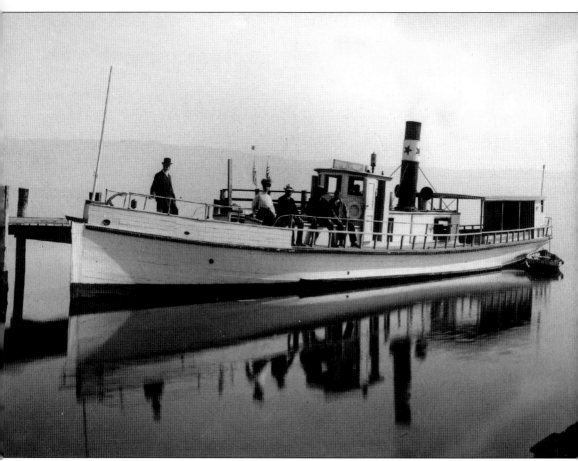

The *City of Lakeport* operated daily during the summer months, but limited her travel during the winter. She connected at Lower Lake with the stage lines coming from Calistoga and the Napa Valley railroad. From Lower Lake she ran to Sulphur Bank Mine, where tourists could visit, crossed over to Soda Bay Resort and continued to Lakeport. Besides regular passengers, she carried baseball teams, cricket teams, fans, excited students, animals, fence posts, supplies, cinnabar, tools, and mail. By 1893, Bartlett Springs had become so popular that the owners decided they wanted a fast connection to and from Lakeport. The Bartlett Springs Company bought the *City of Lakeport* from Captain Floyd. In 1908, she sank at her mooring in Lakeport. She was later raised and broken up.

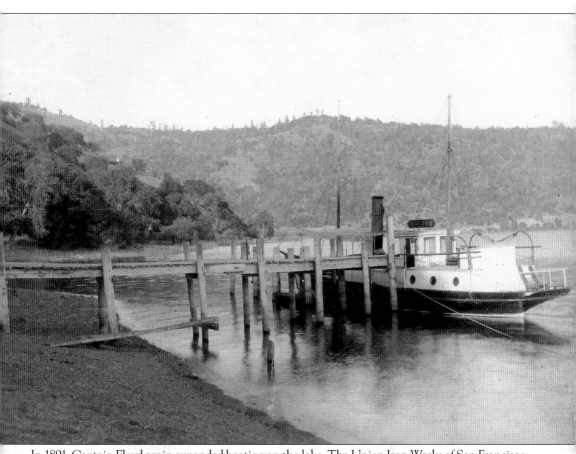

In 1891, Captain Floyd again expanded boating on the lake. The Union Iron Works of San Francisco manufactured an all-metal boat to be used on the lake. The *Whisper* was built by the Iron Works as a "courtesy" to Captain Floyd, who, as president of the board of trustees for James Lick, had awarded the iron works the contract to build the Lick Observatory on Mt. Hamilton. The new and modern *Whisper* was made in several sections. The pieces were transported to Ukiah via the railroad and hauled to the lake by wagons, where she was assembled in Lakeport. It was not until 10 months after Captain Floyd's untimely death that the *Whisper* was finally launched.

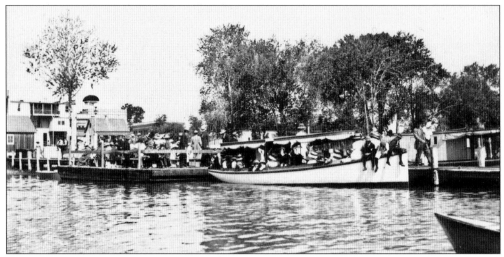

The Ancient Order of United Workmen put on an incredible excursion for several hundred guests in May 1879. Three barges were lashed together and towed by a steam launch named *Independence*. The crowd left in the morning from Levy's wharf. Dancing began and continued without stopping as they crossed the lake to the Morrison Ranch at the northern edge of Lucerne. A picnic lunch was served, followed by speeches, music, games, and contests. According to the local paper: "They returned to Lakeport to the accompaniment of the music of banjos, guitars, mandolins and harmonicas. A happier or gayer party never set sail across the bosom of Clear Lake."

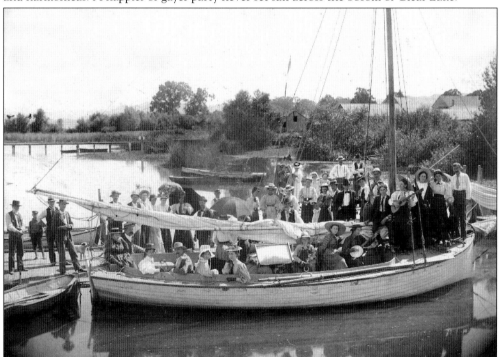

The *American Girl* is filled from bow to stern. Musicians with banjos and guitars play in the bow of the boat. Identified passengers include Lucy Quigley, Annie Crump, Lena Crump, Major Whillon, Judge Sayre, R. V. S. Quigley, Bart Quigley, George Lyon, Fred Greene, and P. Bruton.

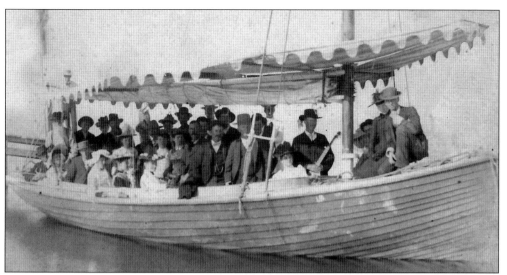

Pictured here is Captain Atherton's sailboat *The Petre*, completely filled and ready for fun in 1900.

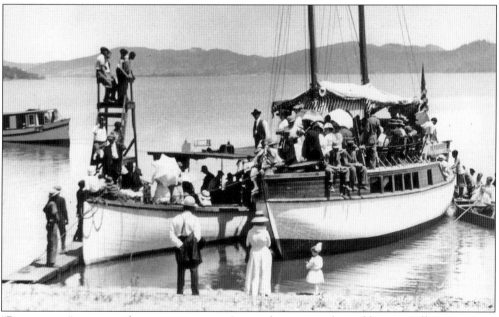

"Boat parties" were popular entertainment. One such party was hosted by Mrs. Lillian Hastings, who, according to the local newspaper, hosted "the social event of 1894." Lillian, the wife of Judge S. C. Hastings, chartered two boats to entertain 90 guests. The paper further stated, "The steamer *Freda* and sloop *Petrel* were chartered, decorated and illuminated with torches and Chinese lanterns, and at 8:00 p.m. [sic] pulled out from Atherton's wharf for Soda Bay, where the 90 some pleasure seekers soon took possession of the place. The Lakeport Silver Cornet Band furnished music for dancers besides concert selections on the boat. At midnight supper was served in the resort dining room, (at Soda Bay) followed by after supper dancing until 3:00 a.m. [sic] When the revelers all disbanded, some returned to Lakeport, and others continued on a cruise around Clear Lake with appointed landings for breakfast (Kono Tayee) and luncheon, arriving in Lakeport the following afternoon."

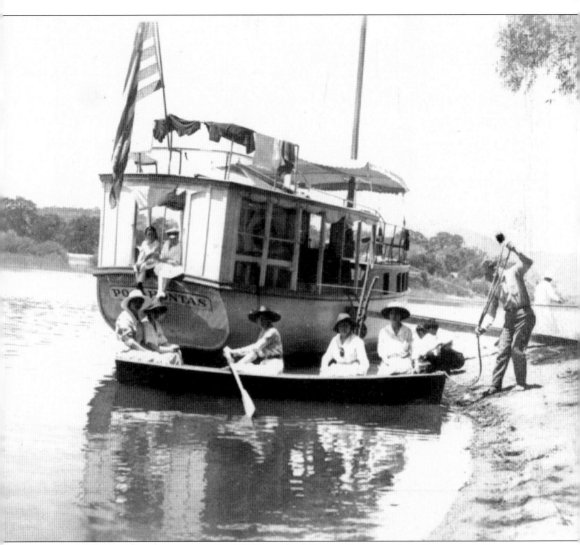

Another popular pastime in the 1890s was to charter boats and make extended excursions around the lake. People camped along the shore at night and continued on the next day to the numerous resorts or estates along the lake's edge. These trips could last from a week to 10 days. The photograph above shows the steamer *Pocahontas*, which was owned by Captain May. She flies a large American flag. Clothes have been hung to dry along her upper deck railing. Children sit on her stern. A gangplank connects the boat to the shore. In the foreground, a rowboat filled with ladies appears ready to strike out on an adventure.

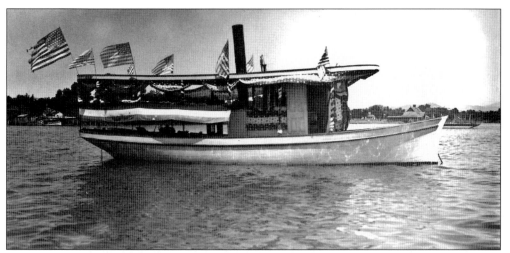

In this photograph, Commodore John Jones pilots his boat *Freda*. Boat parades began in the 1890s and were elaborate affairs. It was common to take groups of people to observe the Fourth of July celebrations all over the lake. Boats covered in flags, bunting, and pennants paraded past the shore to the delight of onlookers.

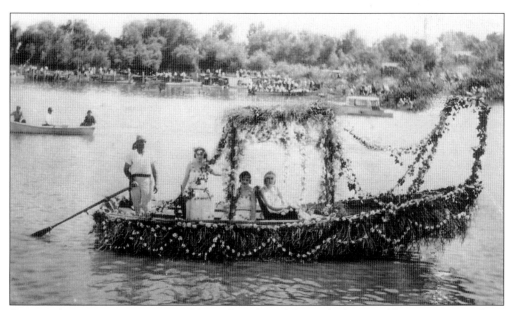

Costumed participants are pictured here aboard an elaborately decorated boat cruising in front of the Lakeport shoreline.

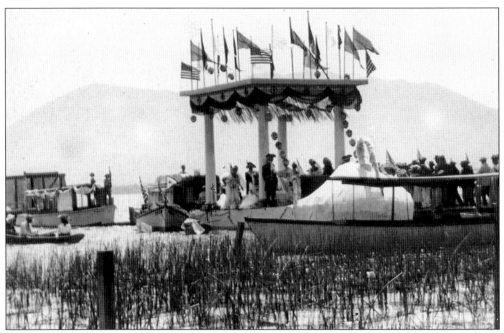

The Venetian Carnival of 1897 was an impressive event. Decorated and illuminated, the vessels cruised slowly past the crowds. Perhaps the most extraordinary float of the carnival was created by Dr. Clarence W. Kellogg of Lakeport, seen in the photographs above and below. His entry was inspired by the Greek myth of Leda and the Swan. Leading up to the evening parade were races for steamers, launches, yachts, and rowboats. A reenactment of the battle between the *Monitor* and the *Merrimac* topped off the festivities, with billows of smoke and flames pouring out from both ships. At the end of the evening, a brilliant fireworks display lit up the night sky.

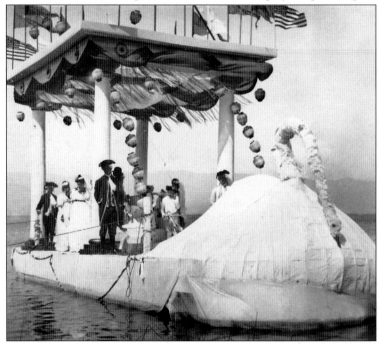

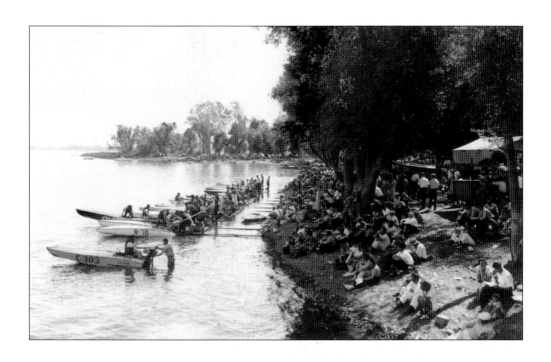

In the picture above, drivers and mechanics ready their boats for one of the national championship races held on Clear Lake in the 1930s. As seen below, the broad, smooth surface of the lake allowed racers to make an all-out effort in the dash back to the finish line at Library Park in Lakeport.

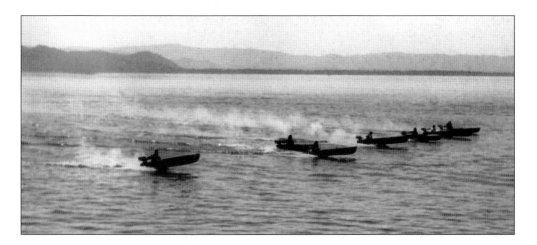

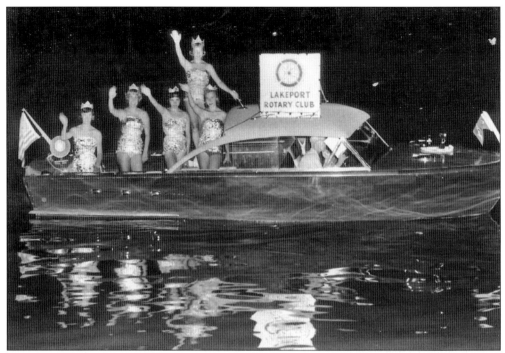

Boat parades have become a traditional part of Lake County's Fourth of July celebrations. In this 1960s photograph, Earl Price pilots his sleek Chris Craft for the Rotary Club. Aboard were Clear Lake Union High School students, from left to right, Jeannie Anton, Susie Crump, Vickie Eickhoff, Pam Peterson, and Jan Devoto.

Pleasure boating, sailing, waterskiing, water boarding, jet skiing, bass tournaments, and quiet fishing from small boats or along the shoreline are still major attractions. Summertime finds Lake County filled with people of all ages enjoying the warm waters of Clear Lake.

Six
TOWNS AND VALLEYS

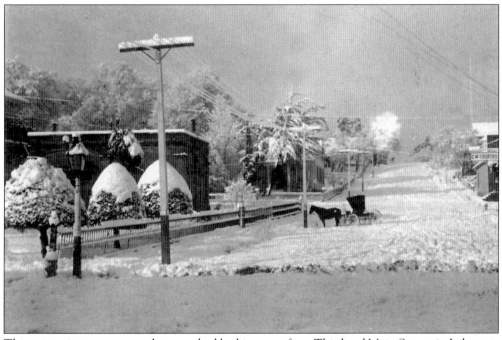

This quiet winter scene was photographed looking west from Third and Main Streets in Lakeport. In the late 1860s, there was an intense rivalry between the towns of Lakeport and Lower Lake for possession of the county seat. This rivalry grew to such a degree that a number of elections were put to the residents to decide the question. Both towns were about the same size. Hence, each election saw a vigorous campaign by both towns for votes from the outlying areas of the county. Lakeport's advantage in these campaigns was that the county seat was already located in Lakeport. Prior to the special election, the wood-frame courthouse mysteriously burned to the ground, along with all the county records, on the night of February 15, 1867. Lower Lake won the election by seven votes. The county seat was moved to Lower Lake, where it was installed in a rented building. The people of Lakeport suspected fraud and presented the matter to the district court at Napa. A recount found that Lakeport had won the election by a margin of five votes. Lower Lake appealed the decision to the state supreme court, but in the interim, the state legislature passed an act authorizing another election that took place May 2, 1870. Lakeport received a majority of the votes cast, and the county seat was moved back to Lakeport on May 9, 1870. A new courthouse was built on the ashes of the old one, this time of brick.

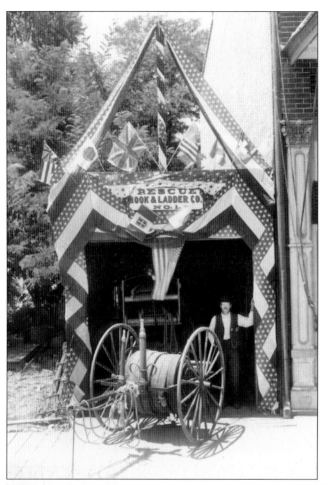

By 1897, the volunteer firemen had raised enough money to equip a fine hook and ladder company. In the photograph below, they proudly display the apparatus in front of the Lake County courthouse.

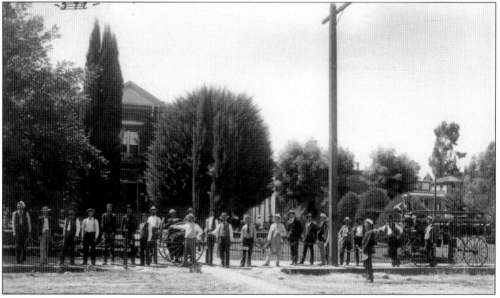

Equipment was stored on the west side of Main Street near the center of town. An interesting array of animals pulled the stagecoach arriving on the right side of this photograph. Gas street lamps lined the boardwalks.

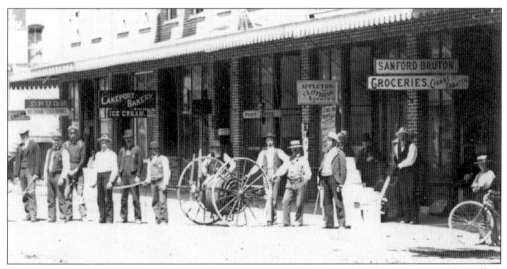

On the east side of Main Street, the firemen stand in front of the businesses in the office building opposite the courthouse: Meddaugh's Drug Store on the far corner, the Lakeport Bakery and ice cream shop, the post office, Appleton's clothing, and Sanford Bruton's Groceries, Cigars, and Tobacco.

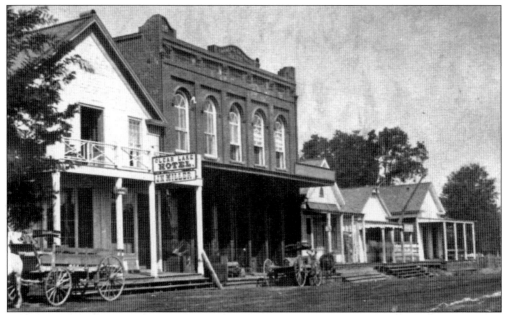

The sturdy brick building erected by the Farmer's and Merchant's Bank was in the center of the block south of the courthouse on the west side of the unpaved street. Two doors north, Charles Slotterbek created guns and pistols that were considered some of the finest ever produced in the United States. People looked for the long, black rifle suspended outside his shop when they had a question for an expert.

The Willis Greene family operated the Lakeview Hotel for a number of years in the late 1890s. The three-story building served as a boardinghouse and provided rooms for travelers. The balcony was a favorite place for observing activities on Main Street.

Druggist O. E. Meddaugh stands in his store, hands in pockets. An avid photographer, Meddaugh recorded scenes of Main Street activities from the balcony of the Lakeview Hotel. He also supplied hundreds of photographs for Lake County postcards and developed everyone's film.

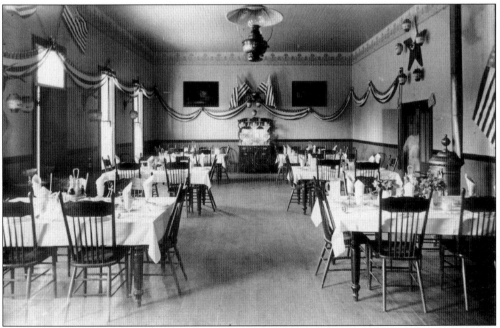

In this view of the Lakeview dining room, bunting and flags decorate the walls. Jack London dined at the Lakeview on one of his trips to Lake County. The *San Francisco Examiner* devoted a full page to London's pictures and a story London wrote. He is quoted as saying, "Clear Lake is like a kingdom of its own, surrounded by mountains, and the only sign of civilization is the chug-chug of the little motor boats on the lake."

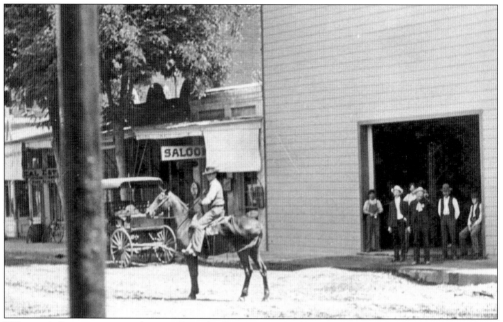

Whitten's Livery was on the south end of town. Tucked between the stable and Bill Moore's butcher shop with the buggy in front, is one of Lakeport's two saloons.

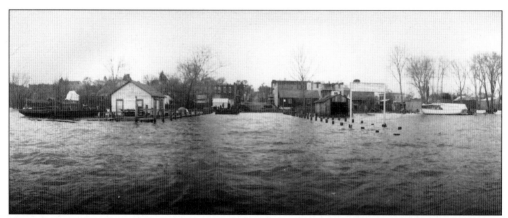

This picture of Captain Atherton's boathouse and dock at the Third Street landing was taken during a particularly wet winter, but the slope of shallow water to deep is quite gradual along most of Clear Lake's shoreline. This made it quite difficult for docking large boats and steamers in the summertime. In 1914, the Yolo County Water Company, who had purchased rights to the water in Clear Lake, built a dredge to deepen the Lakeport waterfront, the Cache Creek channel, and many small harbors and landings.

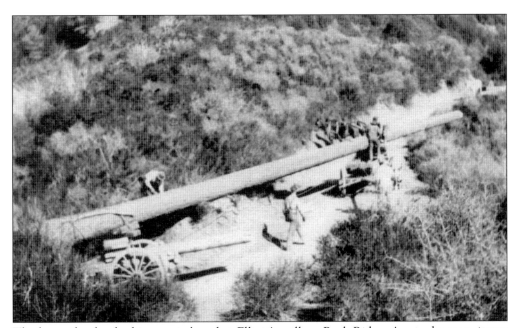

The boom for the dredge was timbered at Elliott's mill on Buck Ridge. As can be seen, it was not an easy task to bring the 80-foot log down from Bartlett Mountain. Tight switchbacks made it a three-day trip. It was brought down the Dennison Toll Road through Clover Valley to the lakefront between Seventh and Eight Streets.

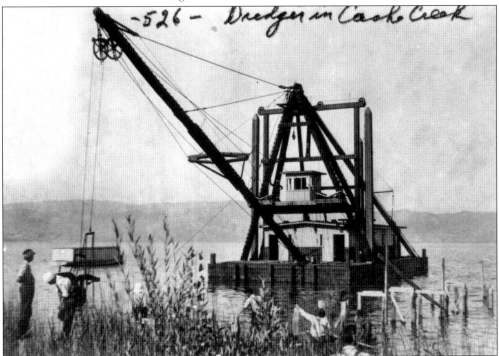

Here the boom can been seen anchored to the barge and rigged with pulleys to maneuver the scoop. The dredge is clearing sediment from the Cache Creek channel. This important piece of equipment worked on the lake for more than 60 years.

It is not unusual to have snow on the mountains in Lake County. Snow at lake level, however, is rare. The U.S. Mail truck leaves Lakeport on schedule, but the trip over the Hopland Grade will be an arduous one.

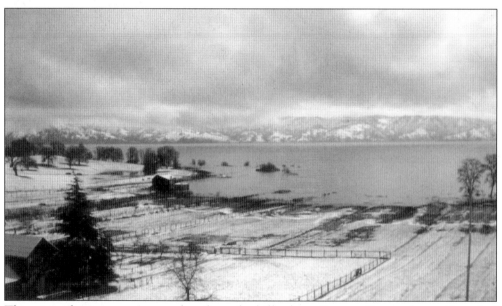

This view of winter snow was taken from the hills above Rumsey Bay at the north end of Main Street.

Built around 1888, the Lakeport Pavilion was between Seventh and Eighth Streets. A bowling alley stretched above the water on the south end of the building. There was a stage in the large main room for theatrical performances, dance bands, and political speeches. Underneath the main floor were boathouses and bathhouses. During boat parades it was used as the judges' platform.

Wilda Green, who grew up on the Gessner Green ranch in Scotts Valley, stands in front of the Hendricks hardware store.

Lafayette Hendricks sold Red Crown gas as well as general merchandise at his store between First and Second Streets on the west side of Main Street.

Herbert V. Keeling is hard at work in his law office in the second story of the Levy Building. Opposite is Willie Johnson, later the wife of Dudley Greene, cashier of the Bank of Lake. Standing is George Neal, secretary of Lake County Title Company. Dick Scudamore, prominent Scotts Valley rancher and stockman, is at the far left.

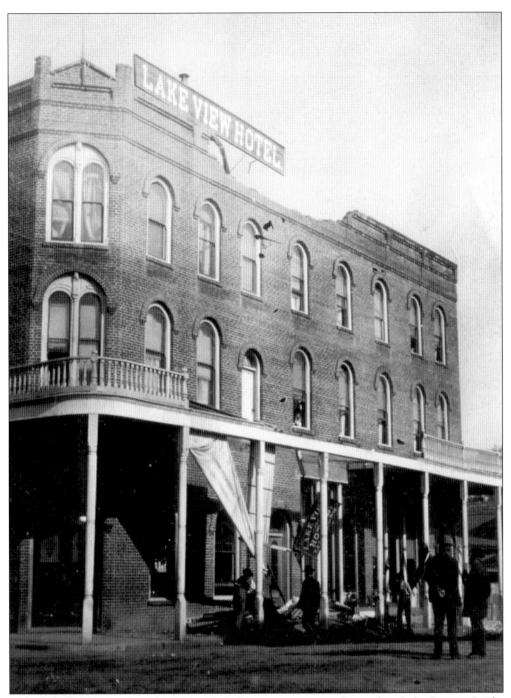

The 1906 San Francisco earthquake triggered seismic activity as far north as Lake County. Bricks fell from the front of the Lakeview Hotel and crashed through the balcony. There was enough roof damage to warrant the removal of the third story of the hotel. Other buildings had minor damage. The Masonic hall was under construction. Its walls were up but had not been structurally anchored. The building collapsed completely. When a fire broke out on this block in 1923, the Masonic hall was the sole surviving structure.

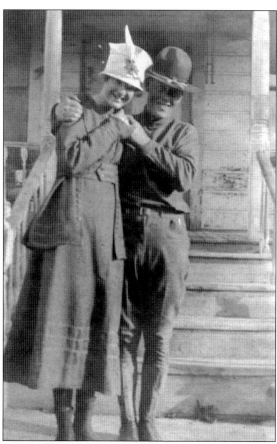

Evelyn Wambold welcomes home a friend at the end of World War I.

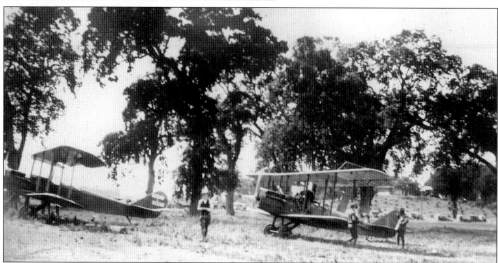

Bi-wing Jennies became surplus after the war. These two showed up at the fairgrounds in Lakeport on a flight billed as "Ocean to Ocean." Locals were invited to "take a spin." On one such flight, a piece of the engine flew off and landed in the passenger's lap. She brushed it off, stomped it through the fuselage, and the plane crash landed in the tules north of town. They recovered the plane and it flew again.

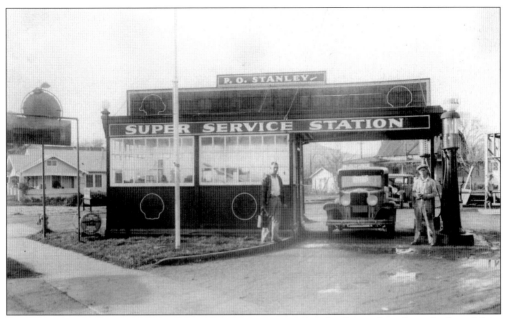

By the 1930s, downtown Lakeport businesses were expanding both north and south along Main Street. At Eleventh and Main Streets, the Super Service Station was run by Park Stanley, left, and Lyle Bucknell, right.

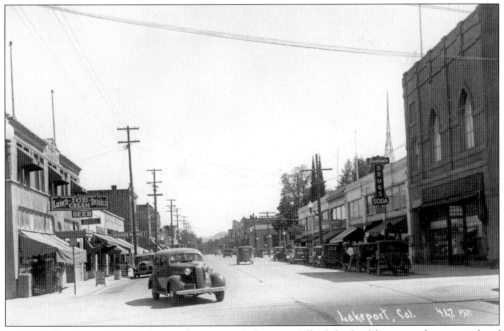

In 1923, there was a major fire in downtown Lakeport. All of the buildings on the west side of Main Street between Third and Fourth Streets—except the Masonic Hall, far right, burned to the ground. The buildings constructed after the fire were limited to two stories by local ordinance.

Picnics and parties continued to be favorite summertime activities for people in Lake County. In this 1920s photograph, Fred Stewart entertains and keeps things lively by playing his ukulele.

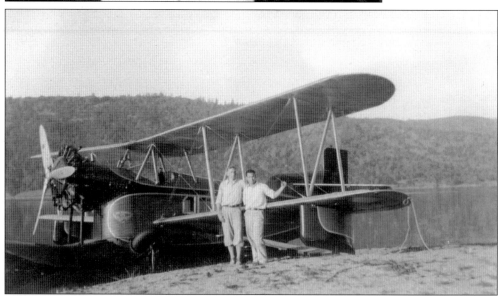

In the early 1930s, Vic Ledbetter and Roz Bishop stopped by to investigate an amphibious passenger plane that was being used to promote air travel to Lake County.

In 1942, friends of Jack Campbell gathered for a send-off party just prior to his deployment with the Seabees. Pictured, from left to right, are (front row) Dr. Thomas Hill, Vi Hill, Norma Ledbetter, Ralph Devoto, and Alice Henderson; (second row) Stella Campbell, Oscar Holdenreid, Vic Ledbetter, Cleo Devoto, Jack Campbell, Babs Busch, Midge Patterson, and Evelyn Norton; (third row) Mildred Bishop, Gail Lafferty, and Eileen Hook; (back row) Dr. Roy Vann, Maxine Vann, Homer Henderson, Fred Norton, Herman Karbe, Rollo Hook, and Harry Lafferty.

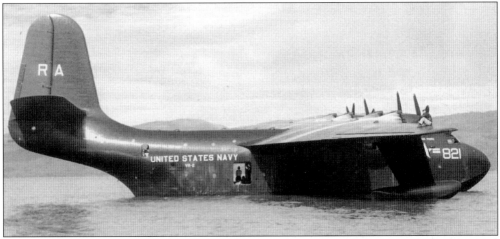

During World War II, Clear Lake was designated an emergency landing base for both MARS tranport planes, seen above, and for Pan American "Clippers." The U.S. Navy maintained a station at the north end of Main Street on Rumsey Bay. When San Francisco Bay, the Alameda Air Base, and Treasure Island were fogged in, planes were diverted to Lakeport. Passengers, military and civilian, were bused to their destination.

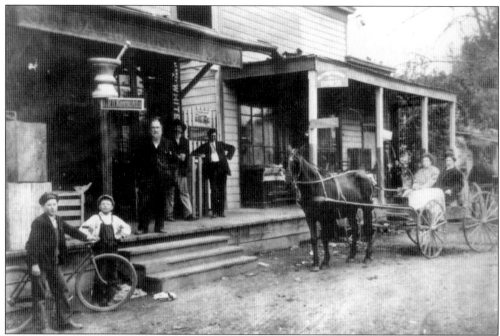

In the town of Upper Lake, Mack and Ted Crowell, far left, Dr. R. G. Reynolds, Jim Mason, Mr. Barnfield, and the two Wilson girls (in the buggy) are pictured in front of the Wells Fargo office. Perhaps they are waiting for the stagecoach to arrive. Upper Lake was on the main road between Bartlett Springs on the east and Ukiah on the west. By 1912, the broad main street was occupied by essential businesses, including a Wells Fargo office, to serve the many farming and ranching families who had settled in the area.

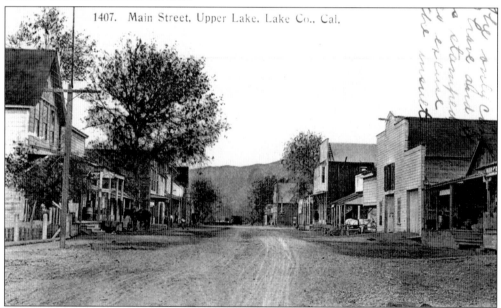

It was popular to transform photographs into postcards as can be seen in this picture of Upper Lake's main street. Dr. Reynolds lived in the two-story home on the left. The Riffles Hotel is mid-block on the right with the ladder on the roof.

The Leonard Alley family lived north of Upper Lake on Middle Creek. Their new artesian well provided water for their alfalfa and hay fields, a walnut orchard, and fine-tasting water for their home. The cannery operated by the Wambold family at Tule Lake adjacent to Highway 20 was a major commercial enterprise. Tule Lake is dry during the summer months, and the rich alluvial soil was ideal for growing green beans. During winter months, Tule Lake fills with storm runoff, as can be seen in the picture below.

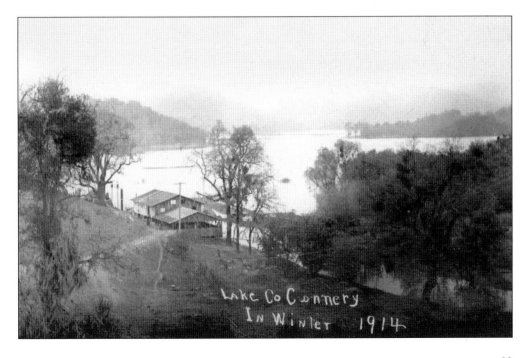

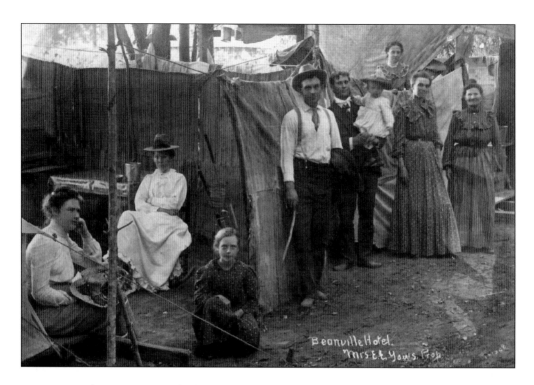

Itinerant workers set up a makeshift camp they dubbed the "Beanville Hotel." Typically the women worked in the cannery and the men maintained the equipment or worked in the fields. The local Pomo, pictured below, were also part of the workforce.

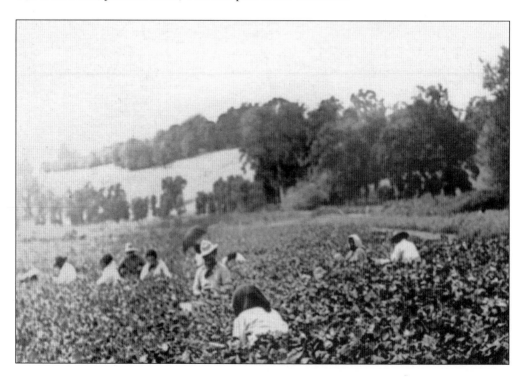

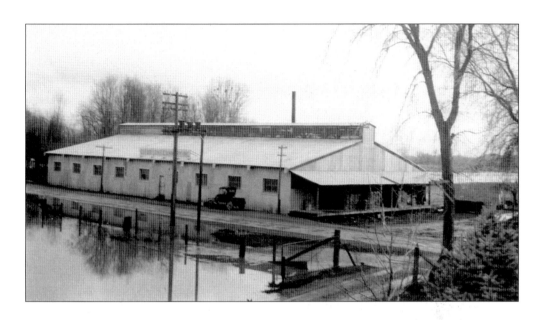

Blue Lake green beans were a favorite of homemakers across the United States. The Tule Lake cannery buildings were eventually replaced by a larger plant in Upper Lake (shown above). In the 1940s, cannery workers wore uniforms and caps to help ensure a sanitary, top-quality product for the consumer.

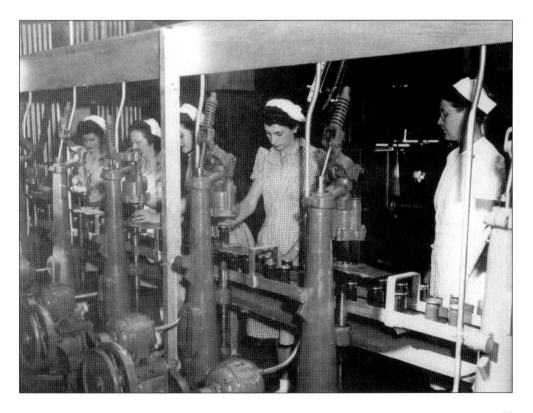

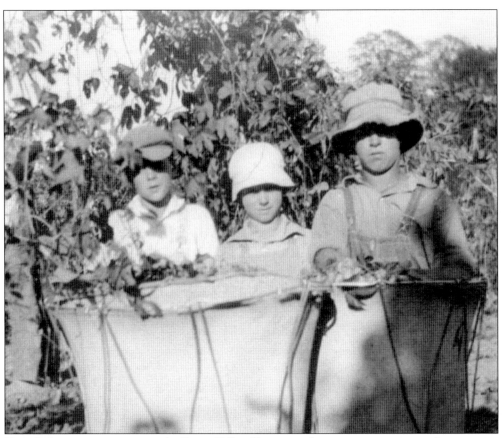

Hops for beer were grown in nearby Scotts Valley. Young people were sometimes pressed into service when it was time to bring in the crop. In 1921, these youngsters helped out in the harvest. After a long hot day in the fields, the nearby Blue Lakes Lodge was a good place to go for a swim.

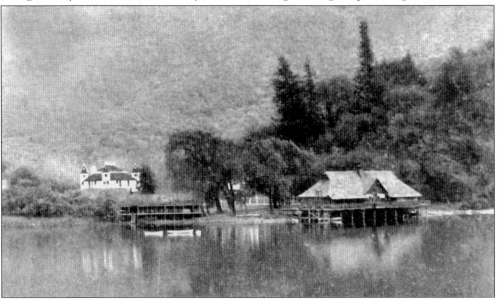

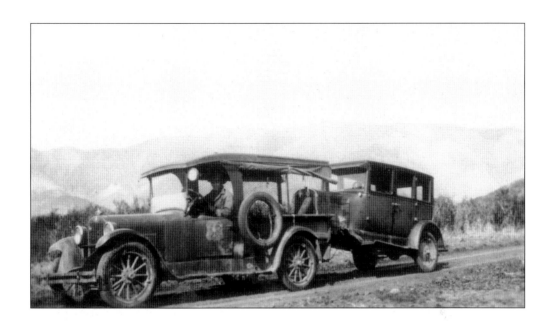

The U.S. Forest Service, headquartered in Upper Lake, not only managed the Mendocino National Forest, established in 1905, but also provided assistance to errant motorists. In winter, the Forest Service plowed the dirt road over the Bartlett summit. Snow intermittently closed the road, sometimes for weeks at a time.

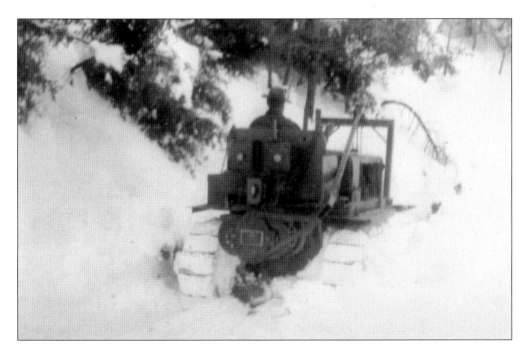

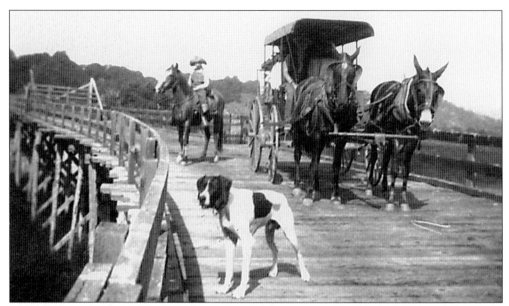

Seen above is the first bridge built by Robert Rodman across the low-lying area where Scotts Creek empties into Clear Lake. The "shortcut" was heavily used. The alternate road to Upper Lake over Scotts Creek flooded in the winter. The concept of elevating the roadway made travel more reliable. Rodman was a man with considerable engineering vision. He had another idea that would dramatically change transportation in Lake County. In January 1919, the Colusa-based Sacramento Valley Development Association submitted a resolution to the California Highway Commission proposing the building of a highway from Lake Tahoe to Ukiah. The proposal was accepted. The process of establishing the exact route became bogged down with political haggling in each county. Locally it appeared that the north shore of Clear Lake, seen in the image below, was too steep for the engineering of a roadbed.

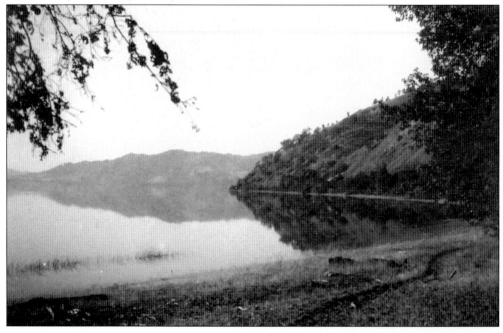

Rodman sent a letter to the State Highway Commission in 1921 suggesting that the state engineer make a survey to determine the feasibility of a highway at lake level. In 1924, the state engineer filed his survey report with the commission. Though the route was five miles longer than going over Bartlett Mountain, the advantages of staying at the lower elevation outweighed the travel distance. The impact on businesses at Bartlett Springs was severe. This photograph shows the beginning of road construction in the area known at Pepperwood Cove.

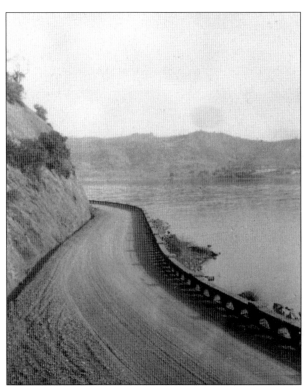

Almost 10 years after the first of several bond issues was passed by the state legislature, the Ukiah-to-Tahoe road, Highway 20, was close to completion in 1928.

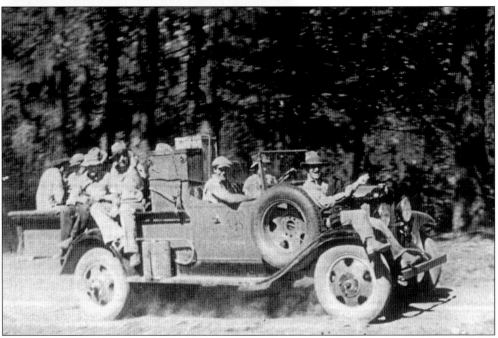

The finishing touch was the construction of a guardrail on the outside of curves close to the lake. This project also included the chain and pillar guardrails along the Blue Lakes section of the new Highway 20. The work was done by WPA crews, one of which is shown here arriving in a Forest Service truck.

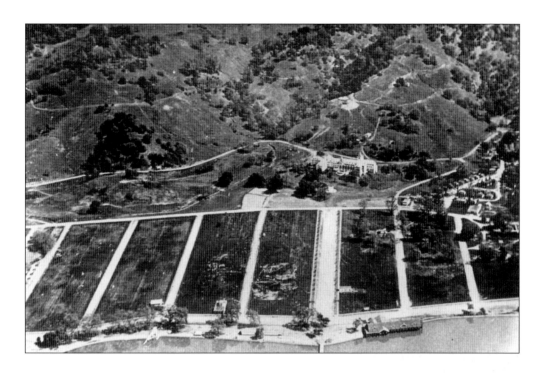

With the completion of Highway 20, the town of Lucerne was developed in earnest. As seen in this vintage postcard, a wide central boulevard from the Lucerne Hotel to the pier on the lakeshore was created. The Lucerne Dance Pavilion was built, and homes and businesses began to line the carefully planned streets.

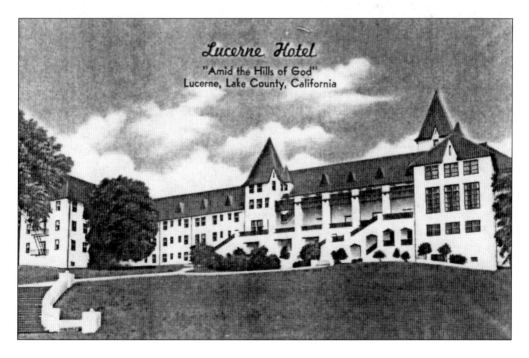

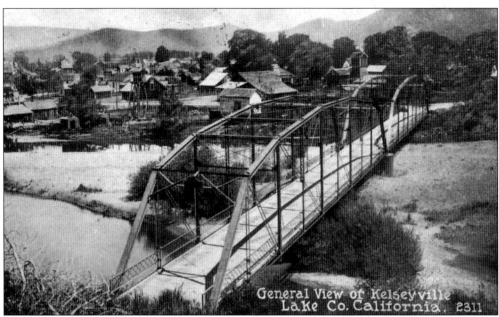

Traces of the dirt trail and stream crossing that led into Kelseyville can still be seen beside the bridge spanning Kelsey Creek. Kelseyville, in the heart of Big Valley, grew slowly. By 1858, a post office was opened.

It was officially listed as "Uncle Sam Post Office" in the records of the U.S. Post Office Department until it was changed to Kelseyville in 1879. The Postal Service of this early era provided exceptional customer service. Mr. J. A. Gunn received a letter from his nephew in England addressed to "Uncle James/Uncle Sam/U.S.A."

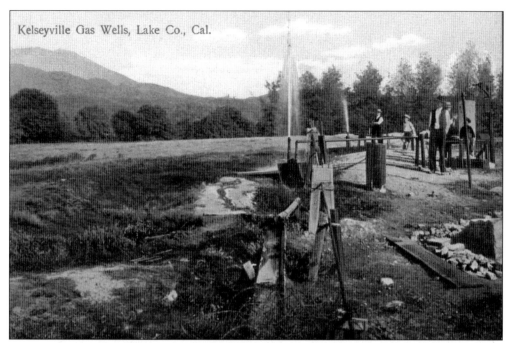

No structures have ever been built on "Gas Hill." Several schemes were concocted to harness the carbonic gas discovered on "Gas Hill" in Kelseyville by John Gard. Drilling for water, Gard's crew had reached a depth of about 15 feet when they began to complain of feeling ill. A doctor was sent for. To test the well, the doctor leaned over and cast a lighted match into the hole. The explosion that resulted removed his hair and eyebrows. His suspicion of "death camp" gas was confirmed.

A three-generation team ran the grist mill on Kelsey Creek for individual farmers who brought their wheat and other gains to be ground into flour. What was not needed for their families could be bartered or sold.

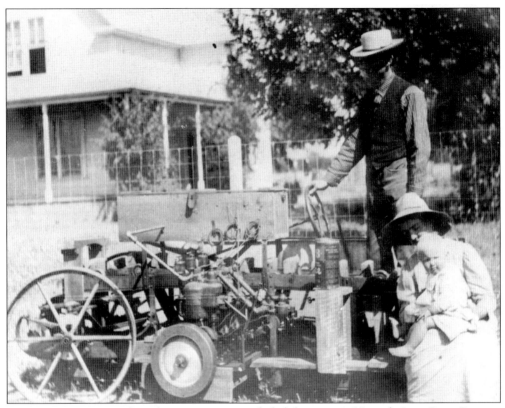
Henry Benson was a tinker whose inventions included this tractor. His wife, Leta Dorn Benson, holds their son Ross on her lap.

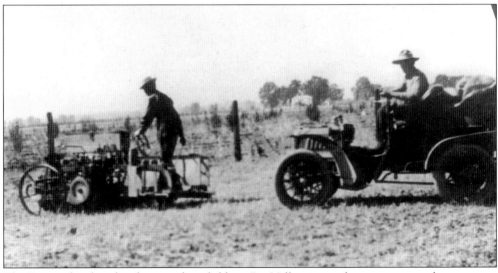
The Benson brothers head out to their fields in Big Valley to put the tractor to work.

The Dorn family settled on the low slopes of Mount Konocti above Soda Bay in the late 1850s. The pear orchards and vineyards they planted and their ranching innovations have yielded some of the finest fruit grown in Big Valley. Pictured above, from left to right, are Leta Dorn, Ludy Dorn, Mattie Dorn, Emma Rich Dorn, and Fred Dorn.

Frank and John Hendricks built this large house on Stone Drive near Finley. Estella Sneed (with the bicycle) is visiting Melvina Hendricks, Joel Hendricks (seated), Grace and Charles Hendricks, and Mary Dillard Hendricks (seated).

The Porter family lived at the Quercus Ranch on Soda Bay Road. Porter managed the extensive acreage for Captain Floyd of Kono Tayee. Much of the fresh produce for the guests at Kono Tayee was grown in the sunny fields of the ranch. Prune orchards and large fields of hay, barley, oats, and hops were also grown. The hop barn, with its traditional raised vents at the top of the roof, is shown below.

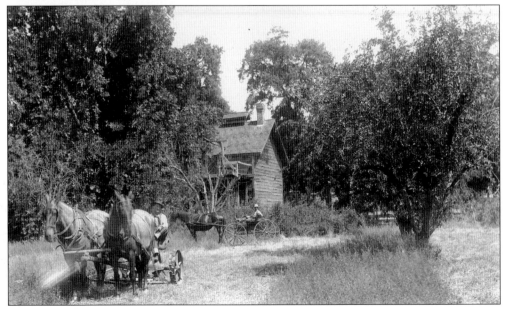

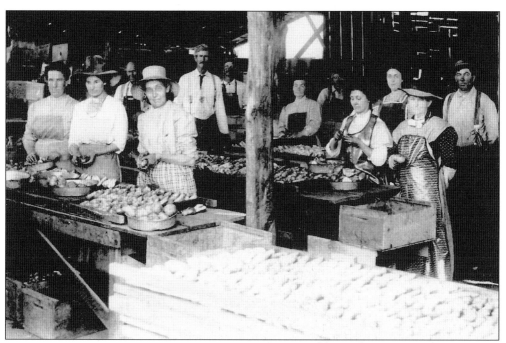

Pears were picked by hand, washed by hand, sliced and cored by hand, and placed on large, wooden drying racks. The racks were moved into the drying yard to cure the fruit before being packed by hand and shipped to market.

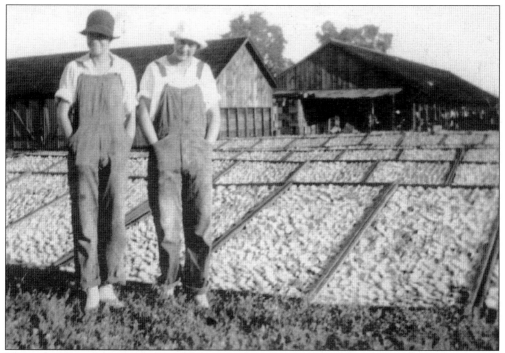

The style of hats had changed by 1918, when these local girls, Claire and Lucille Butler, worked at the Finely Dry Yard.

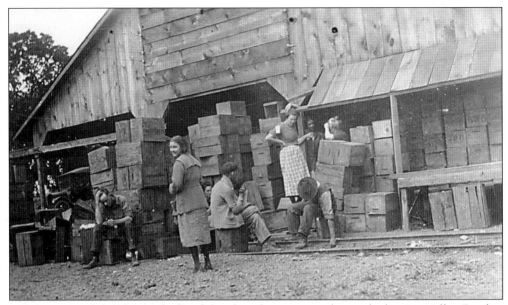

Local teenagers relax during the lunch break at the Morrison drying shed in Big Valley. Bartlett pears were the main crop grown on much of the agricultural land in Lake County. It is purely coincidental that the name "Bartlett" was held by both the popular mineral springs and the crop that was the mainstay of the local economy for more than 50 years. This variety of pear was first cultivated in England in the late 18th century. In 1817, Enoch Bartlett of Massachusetts began growing and distributing the pear using his name.

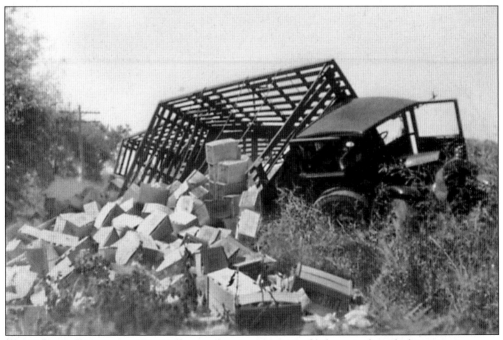

The right-angle curves on Big Valley roads sometimes got the better of truck drivers.

Georgiana Garcia visited her Uncle Pete's orchard in Big Valley around 1944. Many children of ranchers and ranch workers continue in the pear business today.

The Lake Cove Parking Shed in Finley had a good size crew in 1954. Their labels included "Pirates Cove" and "Lady of the Lake."

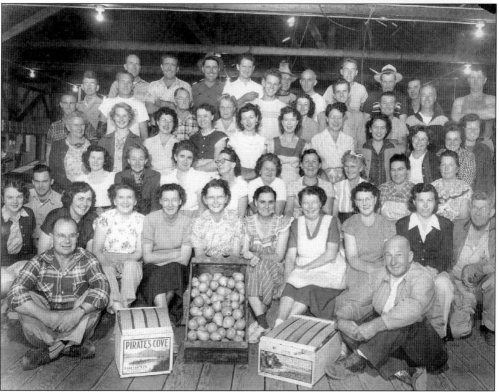

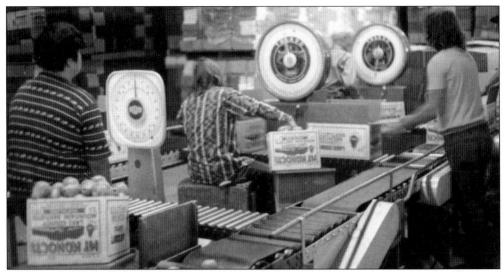

The processing and shipping had changed considerably when this picture was taken in 1953, but pears were still carefully sorted by hand. Those of high quality were hand-packed for shipping fresh to markets across the United States. Blemished and poorly shaped fruit was sent to canneries for processing. The Bartlett is the most widely grown pear in the world and accounts for 70 percent of all United States commercial plantings.

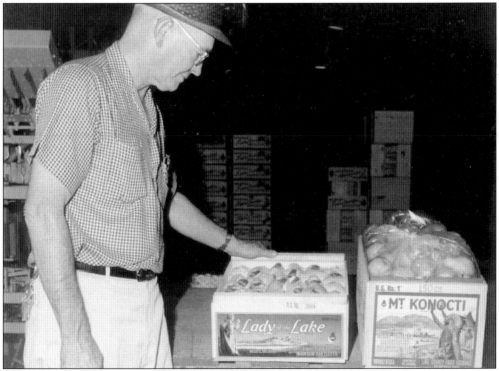

Lake County growers formed the Lake County Fruit Exchange, a cooperative that became the largest pear-packing shed in the county. Located about halfway between Kelseyville and Finley, the shed was a beehive of activity from late July well into September each year. Longtime manager Richard Sanderson checked fresh-boxed pears prior shipment.

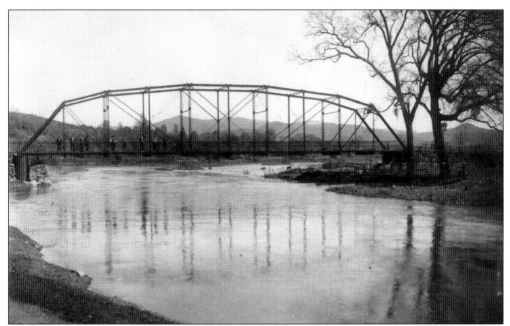

Lower Lake is approached from the north by the bridge over Cache Creek on Highway 29. This span was in place in 1914. The town has anchored the commercial base on the southern most tip of Clear Lake. Wells Fargo maintained an office here to manage the shipment of cargo coming across the lake from the west by barge, steamer, and boats. It was the transportation hub for goods on their way to markets in the Sacramento Valley and to the Bay Area through Middletown.

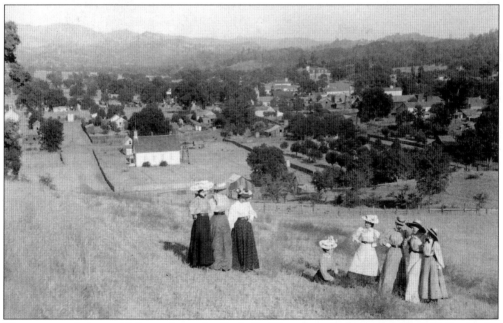

These young ladies are hiking above the Catholic Church at the bottom of the hill. Far in the distance on the other side of town is the Lower Lake schoolhouse, its bell tower rising above the treetops.

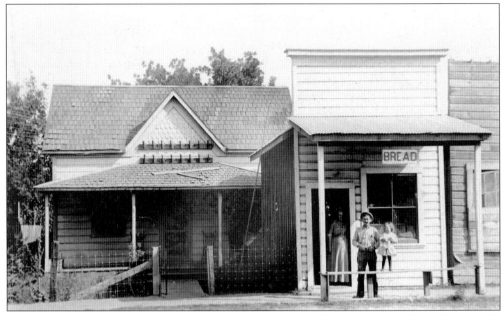

Mr. and Mrs. John Pease ran a small store on Main Street. They stocked candy, cookies, cards, ice cream, and the bread Mrs. Pease baked in their home next door.

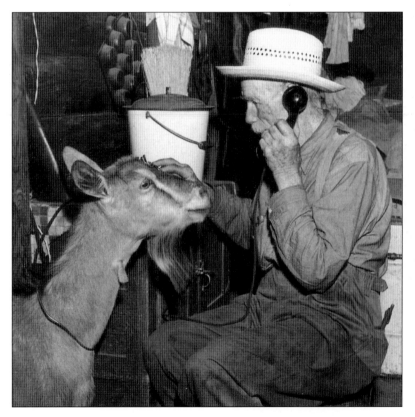

The "Goat Man of Cache Creek" was one of the last people in Lake County to be connected to the telephone system. It took miles of telephone line to connect his cabin to the exchange in Lower Lake.

The sons of 1851 pioneer C. N. Copsey harvest the hay from their fields in the Jericho Valley.

The proximity of the Napa Valley prompted early experimentation with grape cultivation in Lake County. The mild climate and rich volcanic soil was quickly recognized as suitable for wine grapes. At the Wrey Ranch south of Lower Lake, a wine cellar was built of stone. Here Alfred England loads an oak barrel onto the waiting wagon.

Traveler L. L. Paulsen was echoing the visions of local residents when he noted, "the day is near at hand when the shrill whistle of the locomotive will be heard on the shores of Clear Lake." This float in the 1895 Lower Lake parade touted the idea of an electric railroad, but 26 years earlier, in 1869, promoters had organized the Suisun, Berryessa, and Clear Lake Railroad Company. By November of that year, surveys were completed along the lower section near Suisun. A contract was granted for the grading of the route, but the effort was abandoned. In 1879, it was rumored that the Southern Pacific Railroad would bring tracks up the Cache Creek Canyon. Apparently, it was just a ploy to deter other rail companies from a Lake County project. The San Francisco and Clear Lake Railroad was incorporated in 1881, but mention of the project in local papers disappeared by mid-1882.

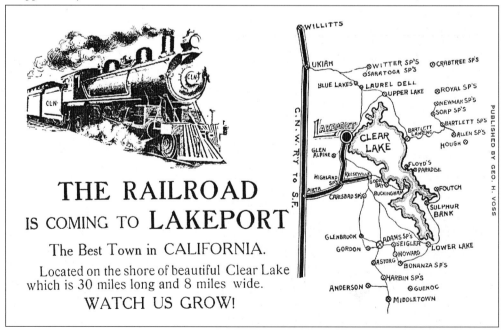

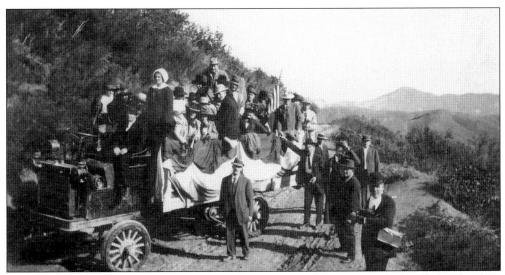

The idea of using electricity, generated by water from Clear Lake, took hold in 1895. It was proposed to connect with the electric railroad that had been built to the head of the Napa Valley. Once again, enthusiasm bloomed—and faded. Fifteen years passed. Determined to finally succeed, a group of citizens in Lakeport organized the sale of stock for a railroad from Lakeport to Hopland. In November of 1911, a large group climbed aboard Clendenin's Automobile Truck and headed to Hopland for the groundbreaking. Other citizens traveled in various cars and motorized coaches. Mrs. Charles Hammond turned the first shovel of dirt. Seven miles of track were laid before the money ran out.

The Lake County Automobile Transportation Company continued to provide services from the train station in Hopland. On this trip, Ray Miller was the driver. Pete McKenna rode beside him, with Katherine McCormack and Joe Levy in back.

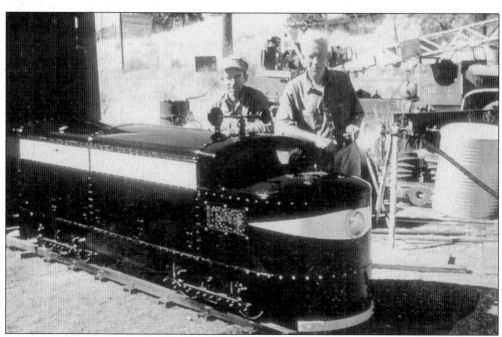

In 1958, Sailor Abercrombie built this train. Tracks were laid in Library Park in Lakeport, and "Pop" Lampson was the engineer. Summertime at last saw train travel in Lake County.

Seven
SPORTS AND RECREATION

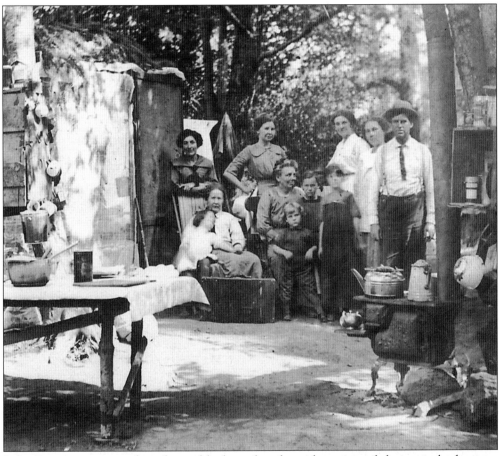

Lake County visitors and residents alike have found a wide variety of choices in both sports and recreational opportunities. Retreating to the cool, pine-covered mountains of Lake County was a favorite late-summer diversion for some local families. William Moore's camp on Bartlett Mountain was well provisioned, and while the men were out deer hunting, the women busied themselves keeping the camp tidy and the children explored nearby. School sports teams have wide community support and faithful fans. Boat racing, fishing tournaments, waterskiing competitions, kids splashing along the lakeshore, hiking mountain trails, bicycling on country roads, deer hunting, a quiet sail on a summer evening, rodeos, and competitions at the Lake County Fair on Labor Day, a Pear Festival in September, sea-plane fly-ins, air shows . . . All this and more have been enjoyed in the Clear Lake Basin.

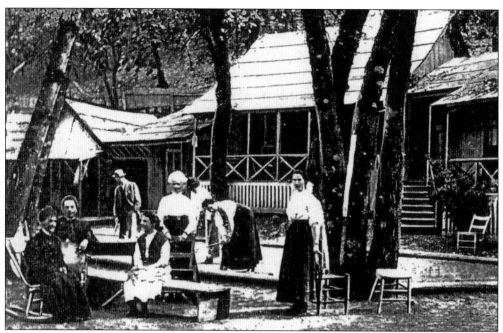

At Anderson Springs, these guests are enjoying a game of croquet in the cool shade of the oak trees while below, just five miles from the bustle of Bartlett Springs, a boxer uses the gym at Newman Springs to train. "Gentleman Jim" Corbett worked out here prior to his fight with John L. Sullivan in 1892. Corbett won the heavyweight championship from Sullivan and went on to be called the "Father of Modern Boxing" because of his innovations in fighting style. He was clever, agile, and "jack-rabbit quick." In 1990, he was elected to the International Boxing Hall of Fame.

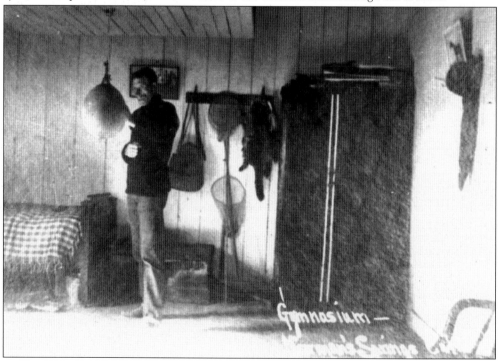

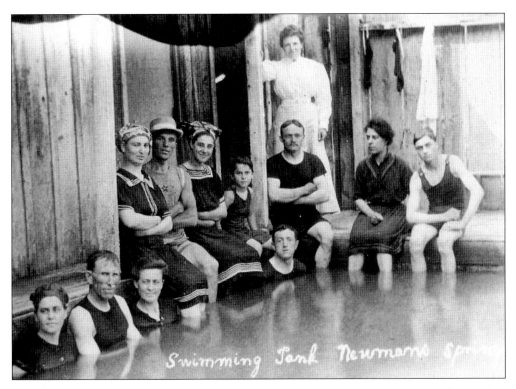

Carl "Bobo" Olson was another fighter who favored Lake County as a training locale. In 1953, Olson set up a training camp at Clear Lake Lodge in Nice for his bout with middleweight Randy Turpin. He defeated Turpin, and *The Ring* magazine named him fighter of the year. When "Sugar Ray" Robinson came out of retirement in 1955, he reclaimed the middleweight title from Olson. The Clear Lake Lodge, below, was built about 1907 by J. Dalzell Brown. It cost about $60,000 and was paid for by money Brown had embezzled from the California State Deposit Company. Brown never lived in the mansion; about the time it was finished, he was sentenced to San Quentin, where he served 18 months. The mansion and the land reverted to Mr. Henry Springe. Bought and sold several times through the years, it has been known as Clear Lake Villas and Clear Lake Lodge, and in 1996 was purchased by World Mark and developed into time-share units.

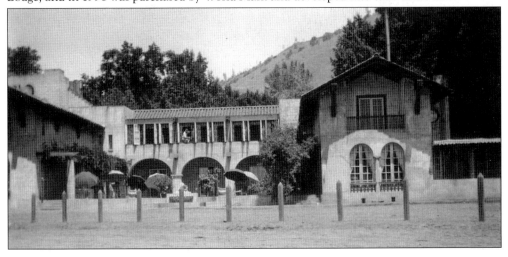

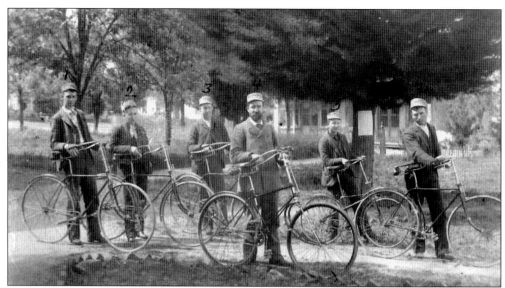

Members of the Lakeport Bicycle Club in 1893 are from left to right, Leonard Cook, Fred Coles, Fred Greene, Al Reynolds, Burt Sayre, and Frank Howell.

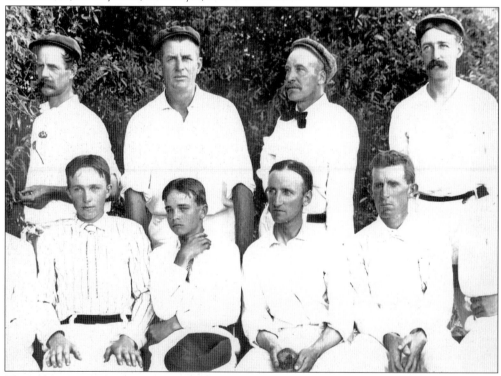

The Lakeport Cricket team, pictured here, vied with the Burns Valley Cricket team. Cricket was extremely popular sport. Fans would travel across the lake by boat to attend matches. The Lake County teams went to San Francisco to compete in a tournament that included teams from Australia. The local paper kept fans at home up to date with results of the competition. Pictured in 1894, from left to right, are (first row) unidentified, Harley Spurr, Herbert Keeling, and David McIntire; (second row) W. O. Edwards, Charles Hammond, unidentified, and Fred Greene.

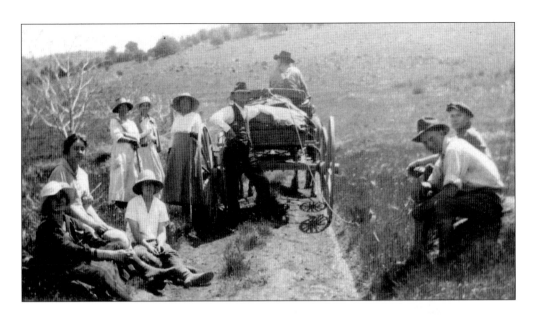

Hiking Mount Konocti was a popular excursion. In 1916, this group takes a rest while the supply wagon, bound for Mary Downen's cabin high on the mountain, passes by. Downen homesteaded on Mount Konocti in 1903 at the age of 59. Although the lack of water in the form of streams or springs deterred most people, it did not stop Mary. She planted an orchard and a garden that she fenced to keep out deer and other animals. Her family joined her in later years, and when she died in 1942, she was buried near the cabin.

When the hikers reached the top of the mountain, they signed the register stashed in a small wooden box. After 1921, hikers were required to obtain a permit prior to ascending the mountain. The register was then kept at Mary Downen's cabin.

Evelyn Wambold and May Roberts hike along Middle Creek.

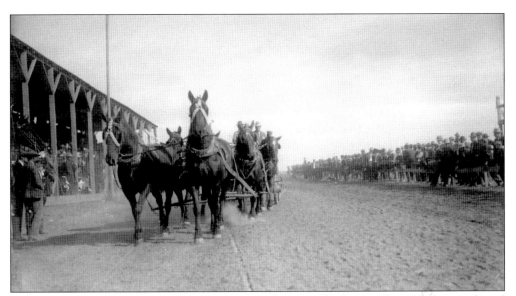
Horse racing was a popular event at the fairgrounds south of Lakeport. Fans fill the stands and line the infield of the track as the maintenance crews groom the oval for the next race.

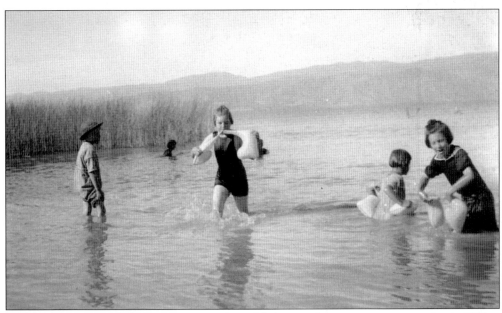
Children were excited about water wings that added a new dimension to summer fun in 1917.

The water in Blue Lakes is deeper and colder than the water of Clear Lake and provides a suitable habitat for trout. The small lakes alongside Highway 20 are a favorite haunt for trout fishermen, as seen in this 1910 photograph.

Vic Ledbetter and Burt Busch of Lakeport traveled to the northwest corner of Lake County to fish for trout in Lake Pillsbury, c. 1930. The lake was created when Pacific Gas and Electric Company dammed the Eel River and built a power plant.

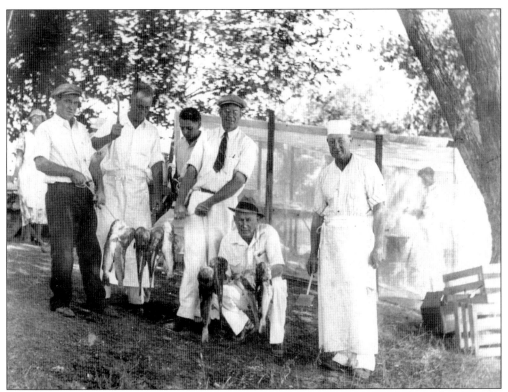

Catfish and bass favor the warm, shallow waters of Clear Lake and the tule beds that line the lakeshore. Beginning in the early 1920s, the Lakeport Lions Club sponsored a Catfish Fry at Library Park for many years. The fish for this event were purchased from Pomo fishermen.

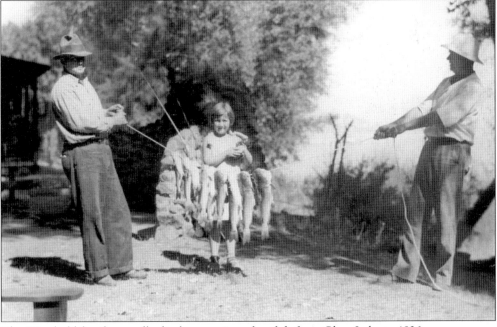

The Wambold family proudly displays a string of catfish from Clear Lake in 1936.

The rolling hills and valley flatlands continued to draw cycling enthusiasts. In 1937, these young housewives set off for a ride in Lakeport. Pictured, from left to right, are Midge Patterson, Eileen Hook, unidentified, Alice Henderson, Norma Ledbetter, and unidentified.

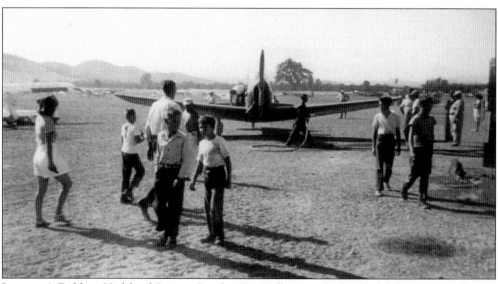
Lampson's Field on Highland Springs Road in Big Valley was the locale for the 1954 air show.

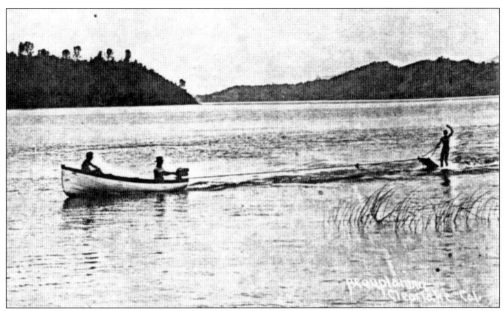

Young people were eager to try the new sport of waterskiing. Fishing boats were called into action and doubled as ski boats as skiers and "boarders" flocked to the lake.

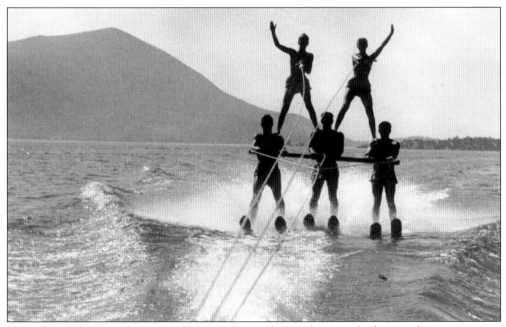

Skiers found the smooth waters of Clear Lake an ideal surface on which to perform.

National Championship Water Ski races were held on the lake's expansive surface as early as 1936. In the 1950s, this unidentified young woman was one of the contestants. Pulled by inboards, skiers skimmed over the water at speeds up to 70 miles per hour. Below, Milt Lange, an avid skier and the individual who led Lakeport community organizers in hosting water-skiing events, presents a trophy to the winner of the day's race.

Eight
End of an Era

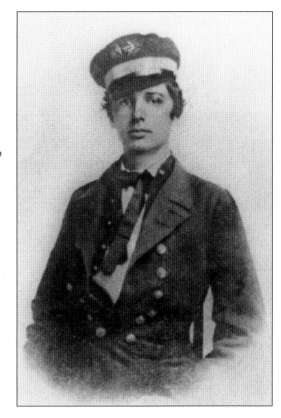

When Richard Samuel Floyd came to Lake County, he came looking for work, not seeking a fortune. He had been born a southern gentleman on Bellevue Plantation in Camden County, Georgia, in 1843. He grew up in a military family, so it was no surprise when he was appointed to Annapolis Naval Academy in 1859. Two years later, Georgia seceded from the Union at the outbreak of the Civil War, and Floyd left the academy, as many young men in both Annapolis and West Point did, to join the Confederacy. His first appointment was on the Confederate steamer *The Huntress*. Later, on *The Florida*, a ship whose main function was to intercept or destroy Union supply ships, he earned the northern designation of "pirate." The blockaders were successful for three years in the Atlantic, but they were finally captured off the coast of Brazil, and the young lieutenant was kept prisoner for the duration of the war.

After his release, Floyd found himself in Europe, then Mexico, lower California, and finally San Francisco. There a carpenter/boat builder named John Fraser told him of a beautiful spot further north with a large pristine lake. There was also work! Floyd traveled the rough roads north, worked in the borax mines as Sulphur Bank Mine, and became enamored of the lakeside landscapes around him. But beauty was not enough, and he returned to the sea's lucrative employment, this time on commercial steamers. In 1871, he married Cora Lyons (pictured here), whom he had met on a cruise to Hawaii. Floyd and his beautiful and wealthy wife honeymooned in Lake County. They regularly resided in San Francisco in a house Cora's father had won in a poker game. Judge Henry Augustus Lyons was a member of the Supreme Court of California; when he died he left a very large fortune to Cora.

The Floyd's first and only child was born in 1873, and they gave her the incredible name of Harry Augustus Lyons Floyd (after her grandfather). Her father called her "Hal," a nickname derived from the initials of her first three names.

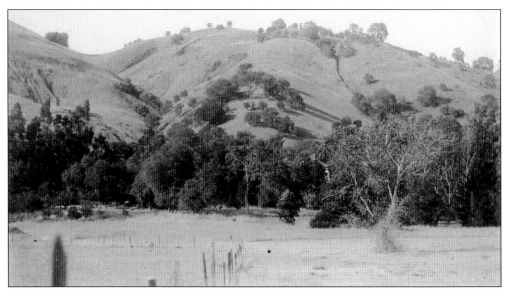

Floyd now owned property in San Francisco, Lake County (Kono Tayee and the mountain behind the house that he named Mount Rouge, Quercus Ranch, Rattlesnake Island, Floyd's Landing, and several properties in the town of Lakeport), Marin County, the cities of Merced and Monterey, and in the San Joaquin Valley. The property he decided to develop was his favorite, a 300-acre peninsula at the west end of Paradise Valley, which he named *Kono Tayee*, meaning "mountain point" in the Pomo language. Captain Floyd purchased the pasture land to build a magnificent summer retreat for himself and his family. He hired Jack and Tom Fraser to build this mansion, which would again allow him to live like a Southern gentleman.

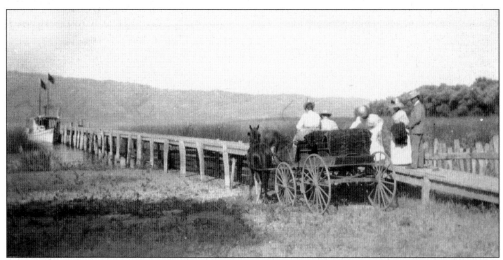

Across the lake at his other property, the Quercus Ranch, Floyd's foreman, Porter, managed agricultural land that produced a commercial income as well as fruits and vegetables for summer guests at *Kono Tayee*. Boats and barges were used to ferry people and produce back and forth between the estate and the dock at the Quercus Ranch.

In 1874, barge loads of redwood, mahogany, and marble were shipped from Lower Lake to the *Kono Tayee* landing. The mansion's foundations were constructed of solid mahogany surmounted by drawing rooms and sitting rooms with 14-foot ceilings. Upstairs were bedrooms and servants' quarters. The family employed a cook, several maids, and a nurse to care for the children of guests. When it was finished, the house at *Kono Tayee* was the finest home in Lake County. Floyd offered his friends a variety of entertainment including a game of billiards on this ornate table in the billiard room.

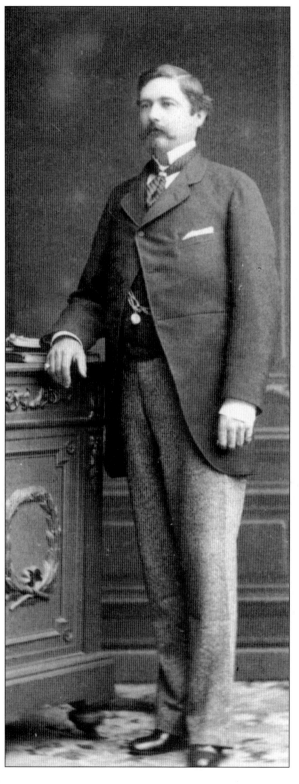

This is an official Lick Observatory photograph of Captain Floyd. Floyd's friend from San Francisco, James Lick, was consumed with the question of what to do with his vast fortune. He was 78 years old and had already suffered a debilitating stroke. Lick wanted to leave a legacy that would last forever—with his name on it. He originally planned to construct a monument larger than the Egyptian Great Pyramid of Cheops in downtown San Francisco—way ahead of the 20th-century Transamerica building. Instead, he was persuaded by the president of the California Academy of Sciences to finance an observatory with what would be the world's most powerful telescope. Mount Hamilton in the Diablo Range east of San Jose was finally chosen as the site for the observatory, after much debate that included consideration of mountain peaks in the Sierra Nevada and Mount St. Helena. As his health declined in 1875, Lick appointed a board of trustees and named Floyd as president. A year later, Lick died, and left the project and a great burden of responsibility in the hands of his trusted friend. Floyd took his job seriously, traveling all over the East Coast of the United States and the great learning centers of Europe, comparing ideas with many scientific minds, and spending the last two years of construction at the site on Mount Hamilton. While Floyd was busy building the world's largest and finest observatory, his wife, Cora, was busy purchasing furniture and decorations for their *Kono Tayee* home. The amount of time and dedication to the construction of the observatory was overwhelming, and when it was finally completed, Floyd was too ill to even attend the opening ceremonies in June 1888. He retreated to his favorite place in Lake County, and used his own telescope to observe the skies.

In 1890, Floyd's San Francisco doctors were increasingly concerned with his health, and sent the captain to a heart specialist in Philadelphia. Floyd's heart was failing and his lungs were congested. He died in his hotel room far from his beloved lakeside home at the age of 47. His wife, Cora, died of pneumonia four months later. Suddenly 17-year-old Harry was an orphan, but a very rich one. She had inherited the combined wealth of her parents, estimated at close to $600,000, to be held in trust according to her mother's wishes, but not to Harry's. She tried to break the will, but to no avail. She continued with the lifestyle she knew, living in the San Francisco home but spending her summers entertaining numerous guests at *Kono Tayee*. She is pictured here as a young lady in 1904.

The gardens at *Kono Tayee* were planted with exotic plants and trees that Harry's father had collected during his world travels. Members of her unpopular trust join Harry (fourth from left) and her friend Elisa Pritchard (directly behind her) during a summer visit. Surrounded by numerous friends her own age, Harry sits on the lower step of the front porch of the mansion.

Watermelons were among the juicy fruits grown across the lake at the Quercus Ranch and enjoyed by Harry's friends. Costume parties, dramas and skits, tennis, and musical performances were part of the lazy summer days at *Kono Tayee*, as were walking through the gardens and down to the dock where Floyd's steamer *The Whisper* was moored.

This photograph shows the Gopcevic brothers, with Milos on the left. At age 30, Harry Floyd's life changed, and according to the *San Francisco Call*, she "announced her marriage to Milos Mitrov Gopcevic, a reported descendant of the royal family of Serbia," though at the time he was working as a cable-car grip on the Sacramento Street line in San Francisco. The couple was married by Judge Morton Sayre on October 6, 1903, in Lakeport. Four months later, Harry contracted measles and died on February 11. She had made out a will 11 days before her death, leaving Milos Gopcevic a major share of the estate, and her devoted companion, Miss Elisa G. Prichard, the family home at 2833 Sacramento Street. The will was contested by members of the Floyd family, but the courts upheld it, and Gopcevic became the owner of *Kono Tayee*. Ownership passed to his nephew on Milos' death, and the estate was sold to a Hayward real estate developer in 1963, reportedly for $500,000. The most charming and exceptional home in Lake County was torn down to make way for a lakeshore development, ending an end to an era that was unique in the history of Lake County. Along the shores of Clear Lake, in the valleys, towns, and mountains, people were creating new images reflecting the changes in Lake County.